digital masters:
people photography

digital masters:
people photography
Capturing Lifestyle for Art & Stock

by Nancy Brown

LARK BOOKS

A Division of Sterling Publishing Co., Inc.
New York / London

Editor: Kara Helmkamp
Book Design: Tom Metcalf
Cover Design: Thom Gaines – Electron Graphics
Assistant Editor: Rebecca Shipkosky

Library of Congress Cataloging-in-Publication Data

Brown, Nancy.
 Digital masters : people photography : capturing lifestyle for art & stock
/ Nancy Brown.
 p. cm.
 Includes index.
 ISBN 978-1-57990-662-7 (pbk. with deluxe flaps : alk. paper)
 1. Portrait photography. 2. Photography--Digital techniques. I. Title.
 TR575.B76875 2009
 779'.2--dc22

 2008038319

10 9 8 7 6 5 4 3 2

Published by Lark Books, A Division of
Sterling Publishing Co., Inc.
387 Park Avenue South, New York, N.Y. 10016

Text © 2009, Nancy Brown
Photography © 2009, Nancy Brown unless otherwise specified

Distributed in Canada by Sterling Publishing,
c/o Canadian Manda Group, 165 Dufferin Street
Toronto, Ontario, Canada M6K 3H6

Distributed in the United Kingdom by GMC Distribution Services,
Castle Place, 166 High Street, Lewes, East Sussex, England BN7 1XU

Distributed in Australia by Capricorn Link (Australia) Pty Ltd.,
P.O. Box 704, Windsor, NSW 2756 Australia

If you have questions or comments about this book, please contact:
Lark Books
67 Broadway
Asheville, NC 28801
(828) 253-0467

www.larkbooks.com

Manufactured in China

ISBN 13: 978-1-57990-662-7

For information about custom editions, special sales, premium and corporate purchases, please contact Sterling Special Sales Department at 800-805-5489 or specialsales@sterlingpub.com.

For information about desk and examination copies available to college and university professors, requests must be submitted to academic@larkbooks.com. Our complete policy can be found at www.larkbooks.com.

contents

THE COOL TOOL

People are frequently active, often spontaneous, sometimes unpredictable, occasionally mischievous, and endlessly fascinating.

I know; I have spent a lifetime photographing them. Today, I shoot with digital equipment, which is perfect for the job—so perfect that I wish it had come on the scene 20 years ago.

Digital is the ideal way to capture the varied moods and moments of the people in your life. It offers new opportunities for you to express your creativity, capture moments, share memories and enhance your lifestyle.

Make no mistake, digital is different from film—in many ways it is better—and we're going to talk about that. Mostly we're going to talk about photographing people, and how to use the potential and the capabilities of digital photography to get the best photographs of the people you know, meet, and care about.

First, of course, you have to be digital-savvy. It is not my purpose here to provide a primer on digital photography. I can offer some basic information, a few tips, and guidelines to help you to get better, more compelling people pictures right out of the gate.

I came to digital the same way most professional photographers did—from a lifetime of film photography. And frankly, I came to it because I had to. The fact is, that one day I looked around and saw that the tools of my art and craft were changing significantly, but that wasn't the main factor that spurred me to make the transition. It became clear to me that the new tools I was seeing were better than the tools I was using—more convenient, more flexible, and faster. Taking a good look at digital, I realized that it would solve a lot of problems for me. And, it would make me a better photographer, just like auto focus, auto exposure, advanced and sophisticated metering, and improved lenses had done years before. In other words, a new cool tool was available, and I wanted it.

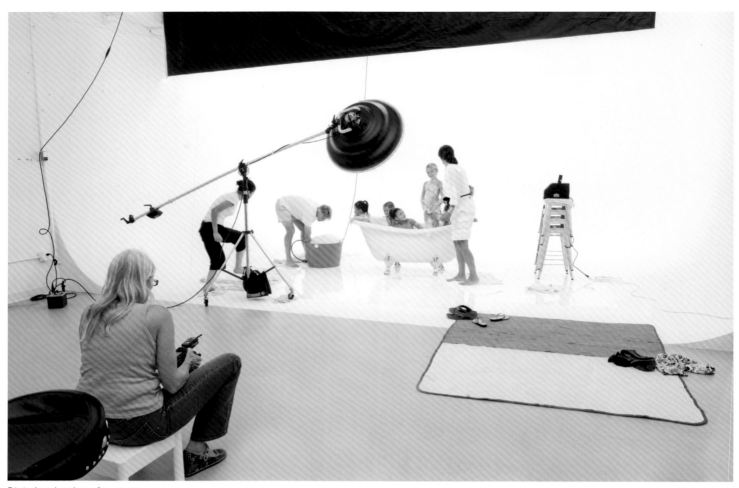

Digital technology frees you up on the shooting side of photography. Since you can immediately see what you've shot, it allows you to get creative and really play around in your shoots. When you know you've got "the shot," then you can go back and explore for more.

Here's a typical incident in a pro's shooting day that reveals just one way in which digital works better than film ever could:

Recently, I had four little girls in the studio for a stock shoot. They were all about five years old, and I'd booked them for a half-day, which would, I knew, come down to about three hours of shooting time. When you're photographing kids, sooner or later—usually sooner—you run into a wall. It is that point at which their interest and energy begin to wane. When the photography stops being fun for them, you're done. We did a bunch of shots around an idea I had—the "stacked heads"—and then I told them to take a break. Then I went to the computer, loaded the photos I'd just taken, and took a good look at them. There they were: Shots that I wanted and needed. I'd nailed the composition, the exposure, and most importantly, the expressions and feelings that I was looking for. Knowing I had it, I could move on to other ideas and other setups. Had this been film, even with all my experience and confidence, I know I'd have thought, "Let's get another roll...or two...or three." With digital, I can use my energy for the next idea.

Here's something very important about digital: Moving on does not mean just getting more pictures; it means—or it should mean—getting more creative. It means saying, "Let's try this," and, "What about that?" and, "I've always wanted to see if this would work." It means more room for experimenting.

One of the prime advantages of digital shooting is that it provides instant confirmation, but that doesn't mean you close the door to experimentation (or to imagination) once you've got what you wanted. Indeed, it's just the opposite, especially when your subjects are as fascinating and rewarding as people are.

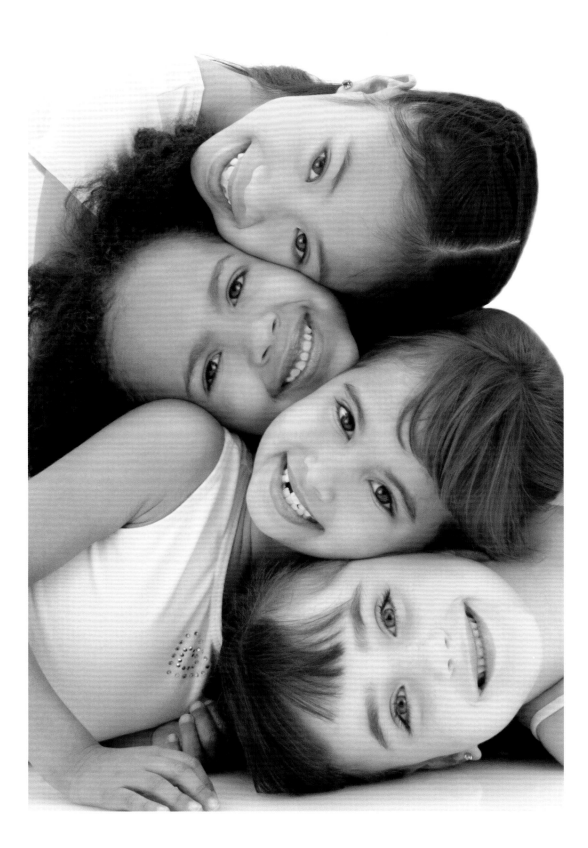

The Digital Age

1

Staying Relevant

Coming from film, I know a thing or two about quality issues in photography—getting a good exposure, tack sharp focus—but the reason I made the transition to digital had little to do with image quality. My philosophy is that you can't live in a cave—this is the modern world, and you have to be open to new ways of doing things. I am also a teacher, and I can't be the only person in the class that has a film camera when everybody else is using digital. My students are going to want to know what to do with it and how to make the same kind of images with the same feeling using the latest technology. You can't negate the essentials of your art simply because you're using a different capture medium. Once I really started going digital, practicing with it, and using it all the time, I found I could achieve exactly the same look I was getting with film—the same feeling, the same people, even the same backlight. You can do it all, and you can make a lot of corrections when you get something close to what you want, or even not quite as close. You can not only fix defects but you can start exploring what you can do with images to make them closer to what you saw in your mind's eye.

This dynamic concept of the image itself is one of the best things about digital imaging, and I don't mean that you have to radically change something all the time, although you can do that too. Just seeing the image you capture as something you can transform right in front of you—make it half a stop lighter or half a stop darker—is liberating. The process is fast; in fact, it's amazingly quick compared to what we did in film days. I'm editing

pictures I shot yesterday right now. They are literally on the screen now as I'm writing this, and it all happened just as suddenly when I made the transition to the new medium. Indeed, it is part of the reason why one day I had an epiphany and thought to myself, "I've got to do this. I've got to learn this—it's here to stay." I mean, how can you not at least try it? I have friends, though, who still won't take the plunge. They say they want that "film look."

Some photographer friends who accompanied me on a trip to Europe are serious enthusiasts rather than pros. Both went back to film after trying digital. They are older people, and for their needs they prefer to shoot film and scan it. They actually like to sit and do the scanning! Well, scanning takes time, and if you can eliminate one process and get right to the finished product, that's kind of nice. This is another reason that digital works for me especially well—we can look at it, get it done, get it out, and burn it to a DVD—it's a done deal. That's the way most pros like to work because there's no time lapse involved. There are some people fighting it, as I did at first, but I think you have to really understand what it is and how it works before you can make a decision whether it is for you or not. If you don't understand it you can't make an informed decision.

Of course, if you're reading this, chances are you're already convinced that digital is the way to go in general—and especially for photographing people—but I thought it would be helpful and motivational to tell you why and how I got here. For me, it was a rational decision rather than an emotional one. Yes, I got there partly because I had to in order to stay relevant in the industry. Once I did, I could really see that digital is a great medium, not only because it's here to stay, but also because working with digital images is actually a good way to explore your own potential. Good things happen when you do.

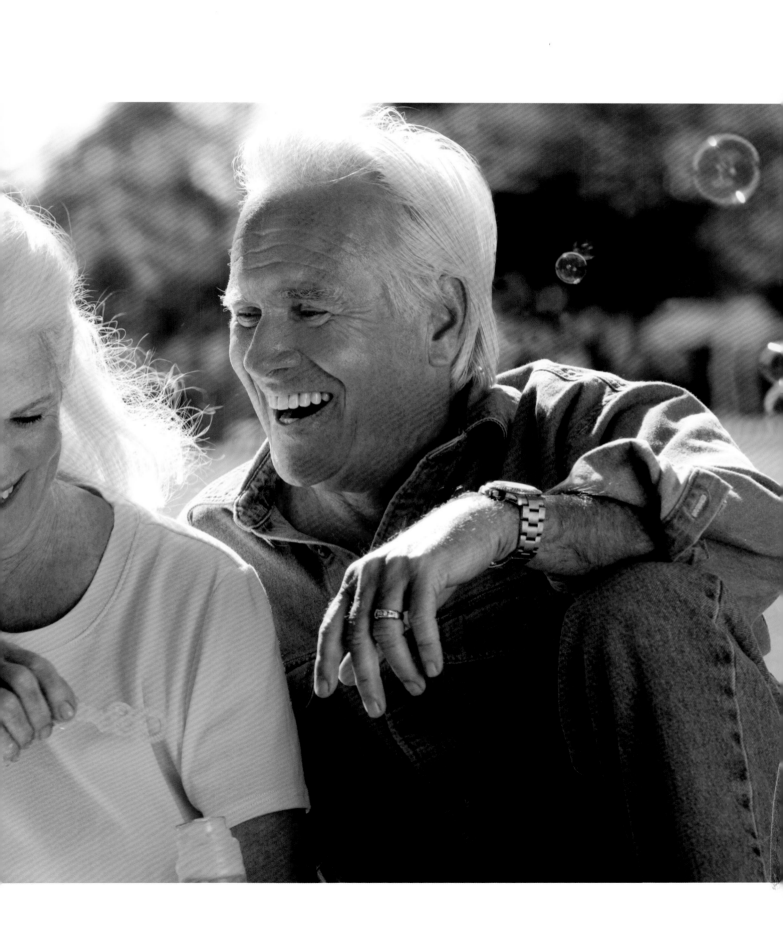

Learn by Doing

I'm the kind of person who learns by doing; before I ever read the directions I start fiddling with the camera. Well, I guess I did read the basic camera operations in the manual before my first digital single-lens-reflex (D-SLR) shoot, but it was still a baptism of fire. Like, "Quick, get the camera out of the box and think about the shooting plan! Models are coming in an hour, let's get this thing out, and read how to make it work." Next thing I know we've got kids in the studio, jumping around in ballet outfits, and I'm reading how to plug the camera in to sync with my studio strobes. That was a rude awakening with my first Nikon D-SLR; you had to mount a little accessory hot shoe-to-strobe attachment on the top of the camera, and I didn't even know I needed one!

At first, I thought there must be a bug somewhere in the camera because there was no outlet to plug my strobes into. I frantically called Joe, my former assistant in New York—who is deep into digital—and told him "I got this camera, Joe, and I'm trying to do some shooting in an hour — where's the sync hole?" He laughed and said, "Nancy, there isn't one." I had to run down to the camera store buy that little accessory. So yes, I learn by doing, even if that means doing it the hard way. I have a difficult time just reading and not having the camera in hand to apply what I'm reading by shooting a picture. It's only then that I understand how it works for me.

Now, I'm not recommending this as a great way to operate, especially when shooting professionally, but I think most photographers benefit from balancing some hands-on experience with reading the manual, and trying out your camera for the first time in a less stressful situation. Begin by concentrating on the most essential things, such as learning to control the autofocus and how to set the white balance. Once you've mastered the basic settings, start shooting, get over to the computer, download the images off the card, and examine what you've got.

One advantage of doing it the hard way—that is, learning about your new camera just prior to an important shoot—is motivation. There's nothing that focuses your mind like the immediacy of, "The models will be here in half and hour, so I better get this right." It's then that I know I can't fool around—I've got to learn how to use it and there's no margin for error. That's how I learn, and it works for me, but I realize that it doesn't work for everyone. The classic advice for anyone with a new camera is "study the manual, know all the controls by heart, and don't shoot an important assignment until you've mastered the camera." If you're a cautious type, a control freak, or simply not a risk-taker, this is a perfectly valid approach. So while my "fly by

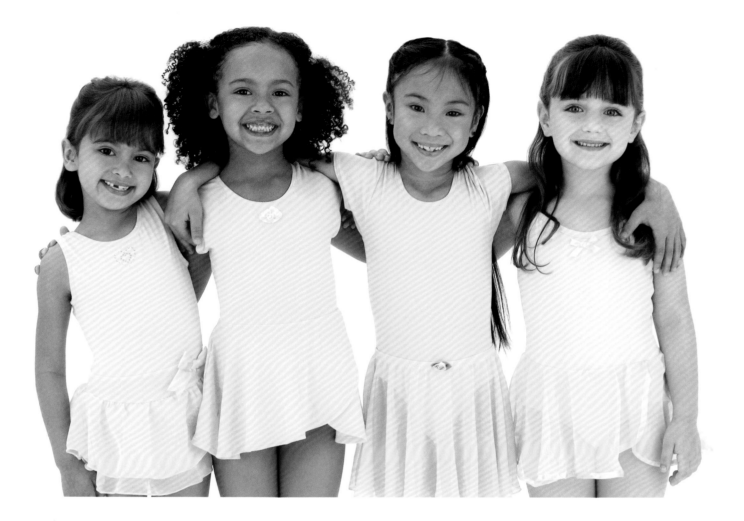

the seat of your pants" method might not be right for every reader, that's how I do it. And if you're like me, winging it can certainly put you on a really fast learning curve.

Learning by doing is especially effective with digital point-and-shoot cameras. If you buy something like a little Nikon Coolpix or Canon PowerShot, isn't it smart to set it to PHD (push here dummy) autopilot mode, take it out in the yard with your child, and shoot some pictures with it? Afterwards you can look at the manual and see what other features, settings, and modes you'd like to try to be creative or get specific effects. Set it to basic settings first and seeing what you get with it. You're getting hands-on experience that will probably help you to use those sophisticated features more effectively. You

can even take this approach with a typical consumer D-SLR—they all have a "green mode" or some such setting so a novice can use them like a point-and-shoot.

That's how I learn—I can't learn the other way. I only read what I need. If I'm having trouble with the autofocus, then I quickly read the autofocus section of the manual, and I find out the difference between single shot, continuous with focus tracking, or whatever. If, like me, you learn by doing, then once you have done it you retain that knowledge. It doesn't leave you. You've done it so you know it. It's not something you just read about. It's kind of like learning to ride a bicycle.

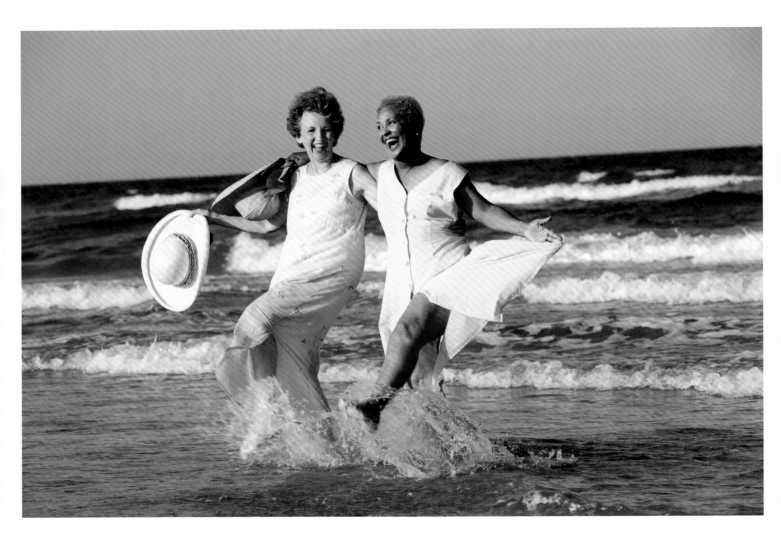

The Learning Experience

To give you a better idea of how I got into digital photography and my present relationship with the new medium, it will help if I give you some personal background. I had been teaching photography workshops at a school in Delray, Florida. The first year I taught there I was shooting film, and I'd say half my class was shooting digital. So here I am watching many of them shoot with digital cameras while I'm still shooting film. We're at the beach running around taking lots of pictures and we're all doing our thing and then I notice these guys stop, look at their LCDs, and smile because they know they've got it. I'm still going on with film, knowing I'm going to have to wait to see the results, and I'm thinking to myself, "You know, this is inevitable; I've got to make the transition to digital because I can see it works." More importantly, I could see how to make it work better. Coming from film, I had a distinct advantage over those who never had a film shooting background. I had disciplined myself to get my pictures right. The exposures and the people had to be right the first time because I couldn't just fix it in Photoshop. With film you have to think carefully before pressing the shutter release. You don't just jump in there, start blasting away, glance at the LCD from time to time and say, "Oh boy, this isn't great but I'll fix this on the computer in post-production." That's the

downside of digital—you don't strive for perfection at the moment of exposure because you think of so many things you're going to do to make the photo right later on.

Of course, this is not to minimize the incredible benefits of Photoshop and other image manipulation and enhancement programs, and here's a story that illustrates the upside. At another beach shoot I was photographing two older women in their sixties. They were in the water, kicking their feet like the Rockettes, just having a ball. I was trying to create some stock images to be sold—maybe for a pharmaceutical ad or whatever—of two women just feeling good in their sixties. And things were going great, but it was hard to get the kicking and everything just right. In looking over my images after the shoot, there was one that was absolutely and totally the best photo, except that one woman's face wasn't as good as it could be—you know, her expression was a little off. However her expression was perfect on the very next frame where the interaction was far less dynamic and convincing. Now that we're doing digital, this is no problem—we just moved the whole head from the second frame and inserted it seamlessly into the first. The result is a real winner that is now with my stock agency.

Granted, it is definitely possible to do this by scanning film images and then manipulating the digital files, but with digital capture this was a piece of cake. Even if you started out with film I'd call that a digital world process, an example of the fact that we're now operating in the digital era. Sure, we've been doing minor things like that all along, but with digital it is so much easier that it has been taken to a whole different level. For instance, on my recent trip to China, I often didn't have a choice. When I was shooting a perfect picture of a rice field and a man went by on his bicycle, he became the unintended center of interest. Now I can simply remove him in Photoshop.

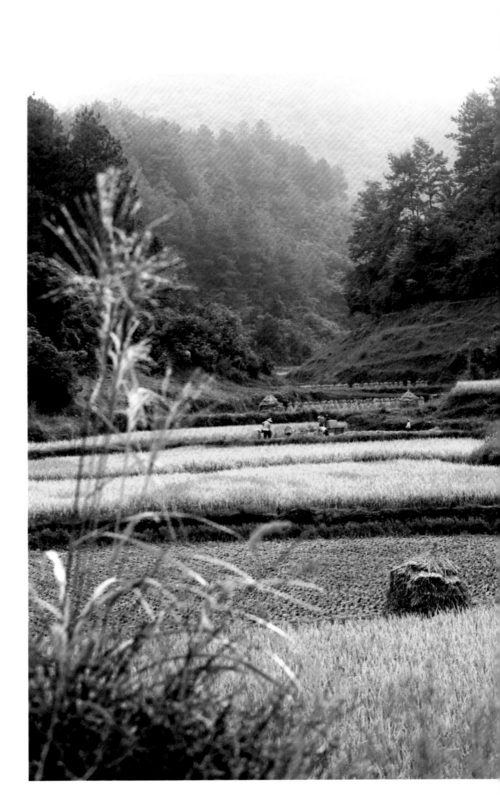

My Cameras

When it comes to taking pictures of people, digital gear provides photographers with a wide array of choices in cameras, lenses, zoom ranges, and even the option of whether to use a point-and-shoot, a D-SLR, or both. You can control the white balance either manually or automatically, change ISO settings from image to image, and easily combine flash with ambient light exposures. The key element is the ability to control light—ambient and fill flash, mixed light, and light at different times of the day. I often arrive early and stay late at a shooting location to achieve maximum control of light and mood. I urge my students to do the same, and it really works. I'm also a bug on avoiding the "rear-view mirror" syndrome—spontaneity lost while checking the LCD instead of focusing on the subject; this is especially true for photographing people. If you are in the middle of a shoot and the energy is good and up, don't break the flow by looking at your LCD!

I don't claim to be a technical expert when it comes to cameras—my feeling is that what is in front of the camera is the most important thing and the equipment you use should be nothing more than tools that make it easier to achieve the results you want. I currently use digital single-lens-reflex (D-SLR) cameras because of the fast response time, eyelevel optical viewfinders, and lens choice flexibility. I love Nikons and have used them for going on 30 years—my current favorites are a Nikon D2X and a D200 (a mid-range D-SLR which I love because it's small, light, and has a 10-megapixel (MP) sensor) and my next camera will be a Nikon D300. I also use a Nikon D40 for casual shooting because it is ultra-light and small. I bought it to photograph my granddaughters just for fun, but I've made some really good RAW images with it.

I use the Nikon 70-200mm f/2.8 zoom lens about 90% of the time because I've always loved making images at wide apertures like f/2.8 and f/4. This gives very shallow depth of field, so the sharply rendered subject really "pops" off the background. One problem for me is that digital is often too sharp, and having out-of-focus elements in the frame makes the overall effect less harsh. I also love catching the "real moment," and this lens helps me to achieve that. In China, I shot with two Nikon D200s; one was fitted with the 70-200mm and the other with a Nikon 28-70mm f/2.8, so I wouldn't have to change lenses.

Point-And-Shoot Cameras

I've shot with digital point-and-shoot cameras like the Nikon Coolpix 2500 with satisfaction and they're a lot of fun. With the latest crop of higher megapixel point and shoots from all the leading camera makers, you can achieve images of outstanding resolution and quality, and the response time on all the new models is much quicker. Capture lag, the time between when you press the shutter release and when the picture is taken, is now nearly the same with point and shoots as it is for D-SLRs. That had been one of the major sticking points that led serious shooters to go with D-SLRs over the smaller compact cameras. However, when it comes to eye level viewing, handholding the camera against your face for maximum stability, and performance at high ISO settings in low light, the D-SLR wins hands down and is by far the best choice for serious digital photography. Indeed, the fact that the available features and megapixel ratings of these cameras have steadily gone up while prices have come down make, them a better choice than ever.

Prosumer Cameras

The only other viable alternative for high-level people in photography is the "prosumer" digital camera (also called "advanced compact camera," "bridge camera," or "digital zoom camera"). This is basically a D-SLR with a non-interchangeable digital zoom lens (generally an 8x to 18x range). These cameras provide many of the essential features you need, often in a relatively compact package, along with a lens that ranges from wide-angle (or semi-wide-angle) to extreme telephoto. One major disadvantage of prosumer cameras is that they have electronic eyelevel viewfinders (EVFs) instead of direct vision optical finders. What you see in the viewfinder is a live feed taken off of the image sensor, which is not quite as clear and sharp as the optical viewfinder in a D-SLR and has a slight time lag that is a huge disadvantage when shooting active or moving subjects. The best of these cameras are very good in terms of performance and flexibility, but the price and size savings are relatively small when you compare them to the current run of D-SLRs. If you're tempted to opt for a prosumer model, don't just buy it on the basis of its cool features—try it out in the store (especially the viewfinder) before you take the plunge.

The term "prosumer" has come to refer to a photographer that falls somewhere between an amateur and a professional photographer. Usually, this photographer doesn't want or need to have the top-of-the-line cameras, nor does he or she want to spend the money on that equipment. The prosumer is a photographer that is able to meet their photographic needs with many kinds of cameras.

Mid-Range D-SLR Cameras

My favorite Nikon D-SLR camera falls into this mid-range D-SLR category, and it takes truly wonderful images. I only shoot RAW image files with this camera, and I don't use it for commercial jobs or stock productions. All the major camera manufacturers make many cameras that fall into this low- to mid-range D-SLR category (Nikon has the D80, D40, D60 series, and Canon has the Rebel series). They have interchangeable lenses, and often come in a kit that includes the camera body, a lens, case, battery charger, and camera bag. These cameras are generally smaller, lighter, and less rugged than the higher-range D-SLRs that are made to be the workhorse cameras that professionals need.

I often suggest a mid-range D-SLR camera when asked, "What camera should I buy? I really love photography and want to make better images, but my point and shoot is not doing it." These are perfect cameras for that photographer because they allow more creativity and technical flexibility but in a more streamlined and inexpensive package.

What to Consider

Personal Preference

This brings me to another very basic point about choosing a camera. What's really important is not which specific brand you go with, but picking one you feel comfortable using. This is especially important when choosing one of the more advanced D-SLRs, because entry-level models aimed at beginners are often easier to operate. I can't stress strongly enough that when choosing a more advanced camera, you should go to a camera store and try it out in person. You've got to be comfortable with all the features, because there are naturally going to be more features when there's more capability built into the camera. Back in the old days, I used the Nikon N90 because it provided simple operation along with sophisticated features. I could do just what I needed with it, but it never got so complicated that it got in the way of making the image. To be honest, I think that most photographers are more likely to have a similar approach to mine than a technology enthusiast. In my experience, they often love all the whistles and gadgets, and everything the camera can do, but that's not me. I want to be able to get sharp, clear images because I'm focused on the image and how to get it, not the technology. I don't care what camera gets it as long as the ones I'm using do. It all comes down to personal preference.

I guess what I'm saying here might be seen as heresy by some photographers who are really into technology—and there are some very good ones who are. But it really doesn't matter to me how the thing works so long as it does. You don't have to understand how a car or a computer works to use it effectively, and the same thing is true for cameras.

Automated Systems

There is one piece of technology that really works for me and I don't know how I lived without it: Autofocus.

I was shooting with 35mm film SLRs long before there was even such a thing as a D-SLR, and that may be one reason I gravitated to the latter. Back in the day, like many pros, I didn't quite trust autofocus (AF) or even autoexposure (AE), but that has changed over the years. Lately, for the first time since I've been shooting, I put more things on automatic, which is similar to the point-and-shoot concept. For the first time in my life, especially as a professional photographer, I find myself relying on AF. On a very recent shoot I used AF all day. The reasons: It's easier, it's faster, the camera's AF systems are better, and my eyes aren't as young as they were years ago. The AF systems in the latest D-SLRs work amazingly well—they're very precise so the pictures are tack sharp, and now the cameras even let you know where they are focusing. You've just got to watch where the little dot or other AF indication spot is in the frame. An important aspect of this is the simplicity of operation—I've seen some AF systems where the readouts are too complicated. It is something you should check out before you settle on one D-SLR system over another.

Image Quality

I recently worked all day in my favorite place—an available light studio—photographing ethnic families, and little kids. We had a laptop set up to the side and every time I shot a card, my assistant Safaa would put it in the laptop. A few minutes later she would say, "Come look at this." I really only came to make sure everything was sharp, but it was great to be able to check sharpness in the middle of a shoot. That's a critical thing with everything I do, especially with today's industry. Stock agencies—like Getty—have gone overboard on sharpness. They'll throw an image out that's absolutely amazing because they can't see a pixel up in the right-hand corner! They are creating an environment where the technicalities are more important than creativity, and that is sad.

The standard explanation is that stock agencies are concerned with the ultimate image use. A photo might wind up on a huge billboard on the side of the highway. The truth is, I have sold billboard images that I shot with 6MP Nikons. I could prove it by showing them the EXIF files (they contain original image information and identification), but I don't even want to tell them because they wouldn't put them in the system. A good example is an image from my first shoot with my then-new Nikon D100 (my first D-SLR). It was a mother and a child on the beach, and it was used on a billboard not that long ago. I showed it to my assistant because we had agonized over it at the time, saying, "Oh my God—these are great images but are only 6MPs." It made a great billboard.

Agencies are particularly over the top about that when they consider sharpness and detail issues. So long as we photographers provide great images that are really sharp where they need to be sharp and they look good, forget counting the pixels, because you're not even looking at the image anymore. There are so many upsides to digital imaging that make it a superior medium for photographing people that I can't even begin to tell you, but this kind of "pixel-mania" is a thorn in my side.

My Lenses

My personal approach to lens selection is as straightforward as my approach to cameras. I realize that the ability to use a wide array of interchangeable lenses is one of the prime advantages of D-SLRs, and many pros that photograph people have impressive optical arsenals. I have no problem with photographers who use a wide variety of different lenses—some of them do very good work—but it's not the way I operate. I currently use a Zoom-Nikkor VR 70-200mm f/2.8G zoom lens 90% of the time. I handhold it; I rarely ever use a tripod. Before that, I used a Zoom-Nikkor 80-200mm f/2.8 in the same way. The new VR zoom with Vibration Reduction (the internal lens optical image stabilization) is even better. In my opinion, image stabilization is one of the great advantages of today's D-SLR systems. I've been handholding an 80-200mm f/2.8 since they invented it, and I'm pretty good with it, but now with all the stabilizers they've made, it gets even better—I get a larger percentage of super-sharp hand-held shots even when I shoot at the longest focal lengths, and even in pretty dim light.

Most portrait photographers understand that a telephoto zoom in the 70-200mm or 80-200mm range is a great lens for people pictures. For me it is more than that; I like to describe it as a "nosy lens." For example, let's say I'm shooting a family on the couch and they're frolicking, and the mom and dad are playing with the kids. And all of a sudden, the mother is on the right and she's kind of static—she's not doing much, and her

expression is pretty bland. So I simply zoom in on the dad and the kids. I eliminate my problem. You can be very selective with a 70-200mm—you can zoom in for a big headshot and the subjects don't even know it, and you can switch to a three-quarter perspective and get the whole group in. It is a neat lens to create a picture story with. You can capture that great moment without the model being aware. I just love that lens—I've always loved that range. It's the only one that will really do it for me, because I'm usually

shooting at wide apertures like f/4. Just yesterday I shot a whole series of images wide open at f/2.8, so the depth of field is very, very shallow. To me, that's how I like pictures to look. You get rid of everything that you don't like, especially distracting backgrounds, and get right in on the people—they pop off the print or screen.

I don't mean to suggest that I never use other lenses. I actually have two other zooms that I use fairly frequently—a standard Zoom-Nikkor 28-70mm f/2.8D and a wide-angle

Zoom-Nikkor 17-35mm f/2.8D. I always take three lenses with me on a shoot and occasionally I use all three, but the bulk of my shooting is with that 70-200mm. My next favorite is the 17-35mm wide zoom, and then there is the in-between one, the 28-70mm. With this optical trio I can cover all I need, and so can you if your shooting profile is similar to mine. Every now and then I'll ask my assistant to hand me another lens if the one I'm using at the moment isn't doing what I want—I always have other lenses available that I take along with me—but basically I use the 70-200mm. I think yesterday I used the 28-70mm maybe twice. Mostly I was using the long zoom. I just like it. You can tell a story with it, and it has worked well for me for many years.

Tip: **A good piece of general advice for serious photographers is to zoom in and get rid of the backgrounds. Developing a positive version of "tunnel vision" and concentrating on the subject will almost always yield more dynamic people pictures.**

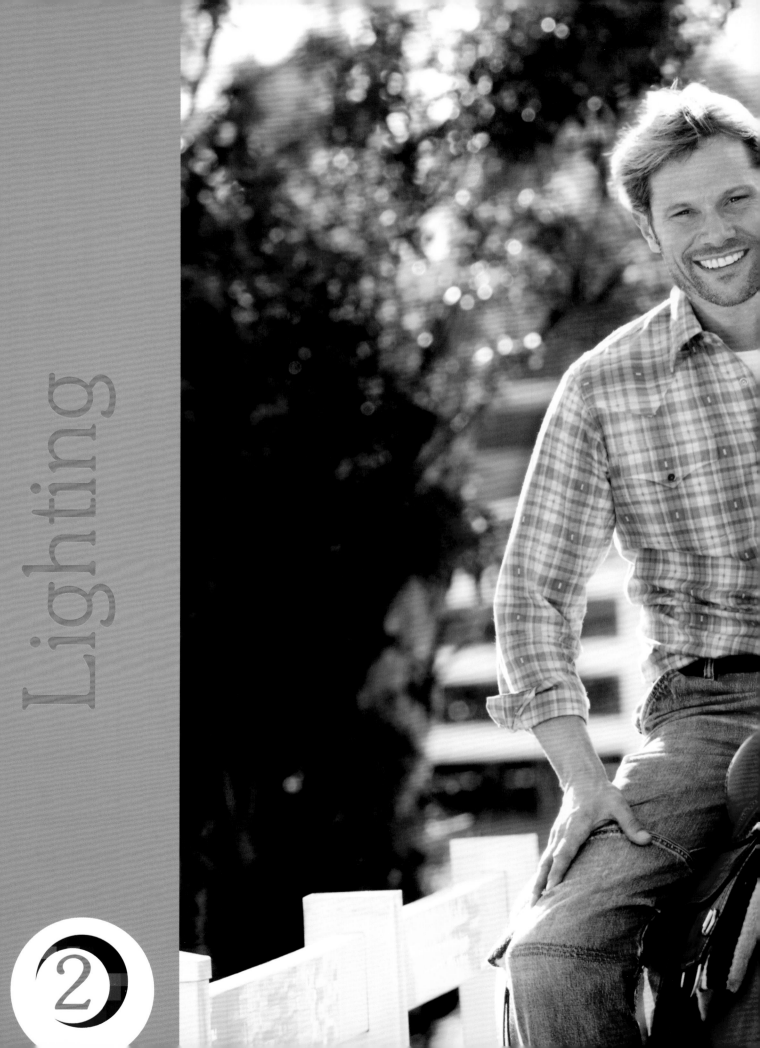

Lighting

②

Lighting, of course, is the key element that distinguishes professional images from run-of-the-mill snapshots. My approach, again, is to keep it simple and straightforward. When shooting outdoors, I generally use natural light and rarely employ on-camera flash unless the client specifically asks for a "flash look." In the studio, I use Dyna-Lite strobes, but mostly what I'm striving for is a look that mimics natural light and does not call undue attention to the lighting.

Flash

Flash can be a stylistic element, and some think the "paparazzi blast" gives a cool look that's reminiscent of fashion images from the '50s or even earlier. It's kind of glitzy—the people in the foreground are in high contrast and everything behind them is visually understated but present. The flash announces itself and becomes the main lighting element. In the studio, we always use strobes to achieve that look. There's no way you're going to get this with a built-in flash, or even a small shoe-mounted unit. I recently had a shoot for Smart Money, and they wanted that "flash look" for a portrait of a woman in front of her home pool. We did some flash because they asked for it, and then we tried three different lighting setups. I did it as they asked me to, but it's just not my thing, so I threw in a few other options. Of course I have the accessory flash units, cords, and whatnot to fulfill assignments like this, and I only used the built-in flash on my D-SLR for fill light and to trigger the other flash units.

Even though direct sun can sometimes be unflattering and harsh, a bright, sunny day also has it's positive qualities. For this shoot, we simply used a reflector to bounce the bright sunlight back towards the subjects. The finished product has a clean, natural, and professional look.

Built-In Flash

The built-in flash on a D-SLR is very useful for anyone, from beginner to pro. I sure made good use of it when I photographed my daughter in the hospital having her second child. I actually took some memorable and well-lit images that ended up being placed with my stock agency. I certainly couldn't set up strobes, so I used that built-in flash for three days. I didn't use it for every shot, of course, but I used it a lot because I was amazed at what it could do automatically. Very few of my images from the hospital had red-eye problems (one of the common downfalls of built-in or on-camera flash), even though I used a telephoto zoom—it was amazing. Of course, many of the latest digital cameras have an in-camera red-eye correction feature so you don't have to Photoshop your images, even if you do get red-eye.

Images shot with built-in flash won't have the harsh flash look if your exposure is balanced for the ambient light; ideally the built-in flash just pops a little light into the darkest shadows (this flash technique is called "fill flash," and is discussed below). That's another great advantage of shooting digital. Flash calculations—especially for fill flash—can be pretty confusing and time-consuming, but many digital cameras automatically calculate the flash output necessary to expose the image correctly. Flash photography techniques certainly benefit from the instant image review of digital technology; you can see the effect right away and correct problems immediately.

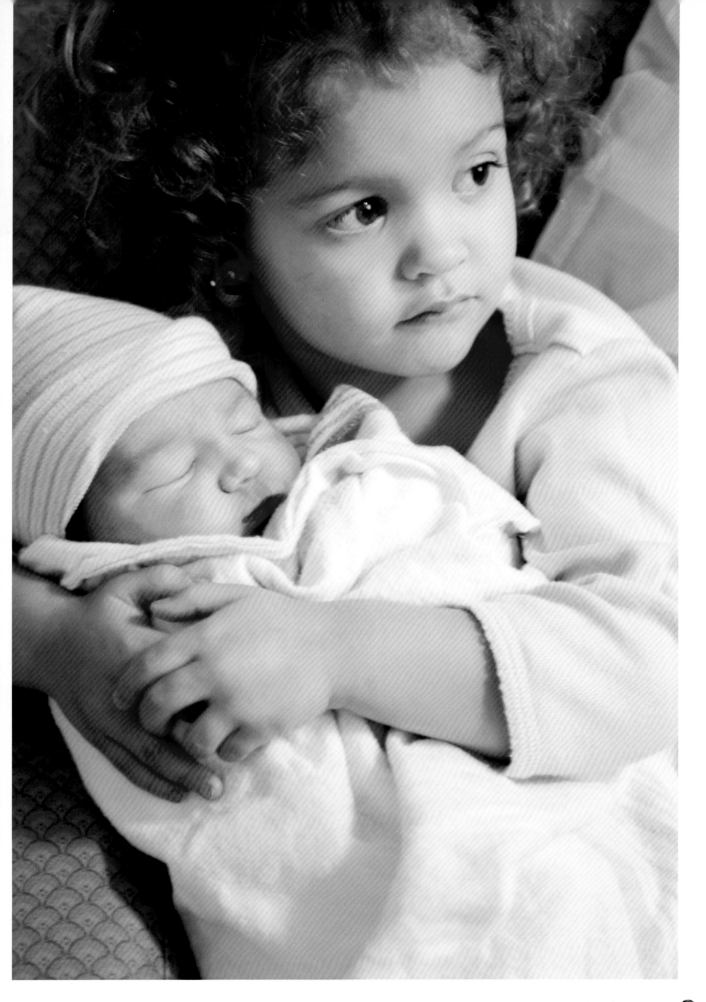

Studio Strobes

In the studio, I use multiple strobes with many heads, and these days they can all be controlled wirelessly. It works extremely well and is far easier to set up than it was back in the days of film, when you had wires strung all over the place and you had to wait to see the results. I don't consider myself a studio lighting guru by any means, but I do have a very clear idea of what I want, and I was surprised at how easy and fast that was to achieve. I think digital lets you get on a much steeper learning curve when it comes to professional studio lighting because the automation is far easier to control and you have instant feedback on any given lighting setup. It offers you a wide range of different ways to control the lighting effect—you can have flash all the time, never, or when necessary. I found my first foray into modern wireless studio lighting to be an amazing experience. As soon as I started using it, I checked my first few images and I said, "Whoa! This is really working."

Rim Lighting

One of the most dramatic lighting effects you can use for portrait photography is rim lighting. Rim lighting means you have most of the light coming from the behind the subject; the main light source is positioned so that the subject blocks most of it, and the effect is a halo of light around the edge of the subject's figure. It is a common technique—especially in Hollywood—as well as being very effective.

One of the looks I like with this technique is to set up the backlight to rim the subject's body and hair, and this works only against a dark background. The lights behind subject are very strong, but they're a good distance away so they don't blow out the exposures. The only light hitting the subject from the front is from two reflectors bouncing the rear light back toward them. I can control how much light hits the front of the subject by moving the reflectors; I move them closer for more detail and light, and further for a softer silhouette look. This goes for the rim light too—the further it is from the subject, the softer the rim of light will be. If I move the rim light closer, I'm getting a pretty strong illumination; I have to watch for lens flare in this situation, but it is a technique that gives great results when you learn how to control it.

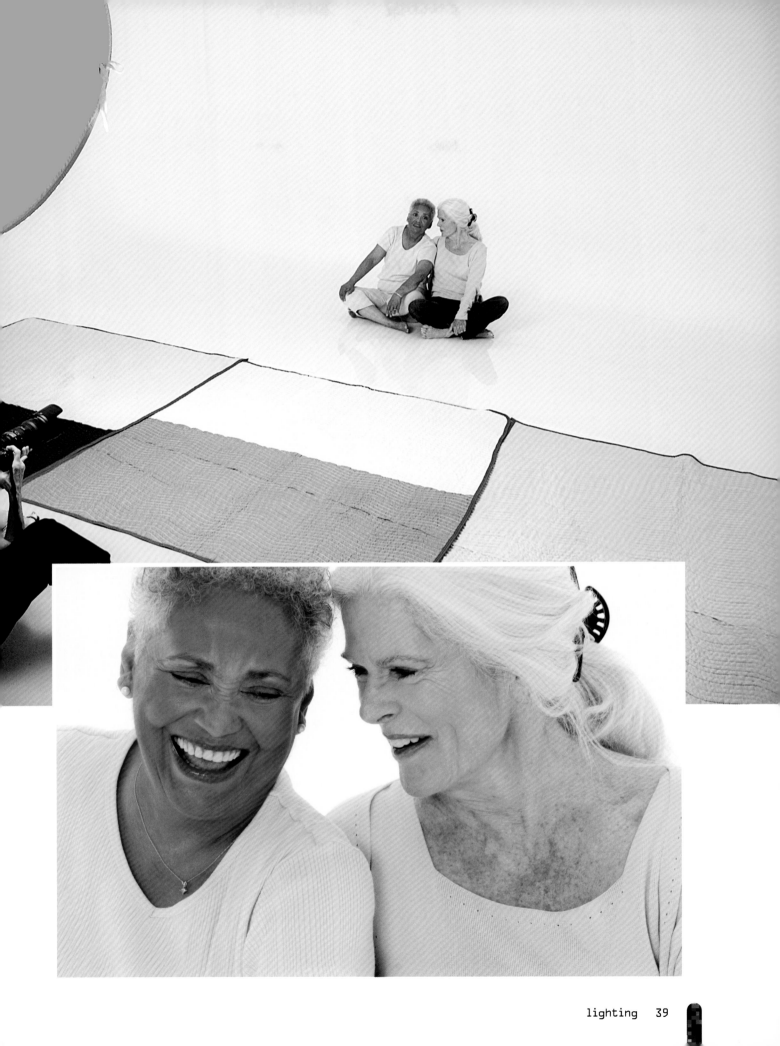

Auto-Balanced Fill Flash

Another thing that is working with the dedicated flash systems built into today's D-SLRs is automatic-balanced fill flash. Because the exposure latitude of digital camera sensors is somewhat narrower than, say, color print film (which gives you about two stops more on the underexposure side and four stops on the overexposure side), finding ways to reduce the brightness ratio of the actual subject is extremely important if you want to avoid blown-out highlights, poor shadow detail, or both. The auto-balanced fill flash is one of the easiest ways to tame harsh lighting ratios (the difference between the brightest highlights and deepest shadows). An automatic option that controls the output of the camera's built-in or accessory flash and

the ambient light portions of the exposures can provide natural pictures of people that don't look as though they were taken with flash at all. Most systems provide ways of altering the flash-to-ambient light ratio so you can dial in a range of different lighting effects and choose the one that works best for your particular subject. Your D-SLR's manual or the manual that comes with the accessory flash unit should provide full details on how each system operates. Whichever system you choose, auto-balanced fill flash is one of the most useful lighting techniques for producing great pictures of people under a wide range of lighting conditions.

Diffusing Light Sources

Lighting is not only about bringing out mood and detail; it is also about hiding imperfections, and this is where you must arrange your lighting to suit your model or subject. Hard, high contrast lighting isn't going to work unless your model is very photogenic. Diffusing the light is the answer for most subjects—it softens the light and the results are very pleasing, especially for people photos.

White Nylon Cloth

Another very useful item for anyone who shoots digital people pictures under natural light is the very opposite of high tech—it's a large piece of white nylon parachute material, which we always throw into our camera case. You can get it on Canal Street in New York City, or Google sources online. You can use this as a reflector (to bounce available light into shadow areas of the subject), as a diffuser (to modify or block harsh light falling on the subject), or even stretch it between light stands and shoot through it to get a romantic, soft-focus effect. It also makes a very good diffuser for a huge bank light—we can light a whole room that way. If you stretch it 20 feet (6.1 meters), put six strobes behind it, and take the shot, you can get some amazing images. It's an incredible thing, you don't have to carry bank lights; you don't have to carry diffusers—just stands, clamps, and this bolt of material. You can shoot it thin or you can double it—it's totally versatile. You can just shoot right through it, or put it on an umbrella and bounce through it to achieve really soft lighting. It's terrific. I've been using it for years to light both large and small areas, and since I'm in Florida now and I shoot at the beach so often, it has become an indispensible tool (a big, transparent umbrella works the same way). My only caution about using a big bolt of parachute nylon is this: Over the years you'll have to buy a new one every now and then because it yellows, and when it yellows, so do your photos (see the section on color casts on the next page).

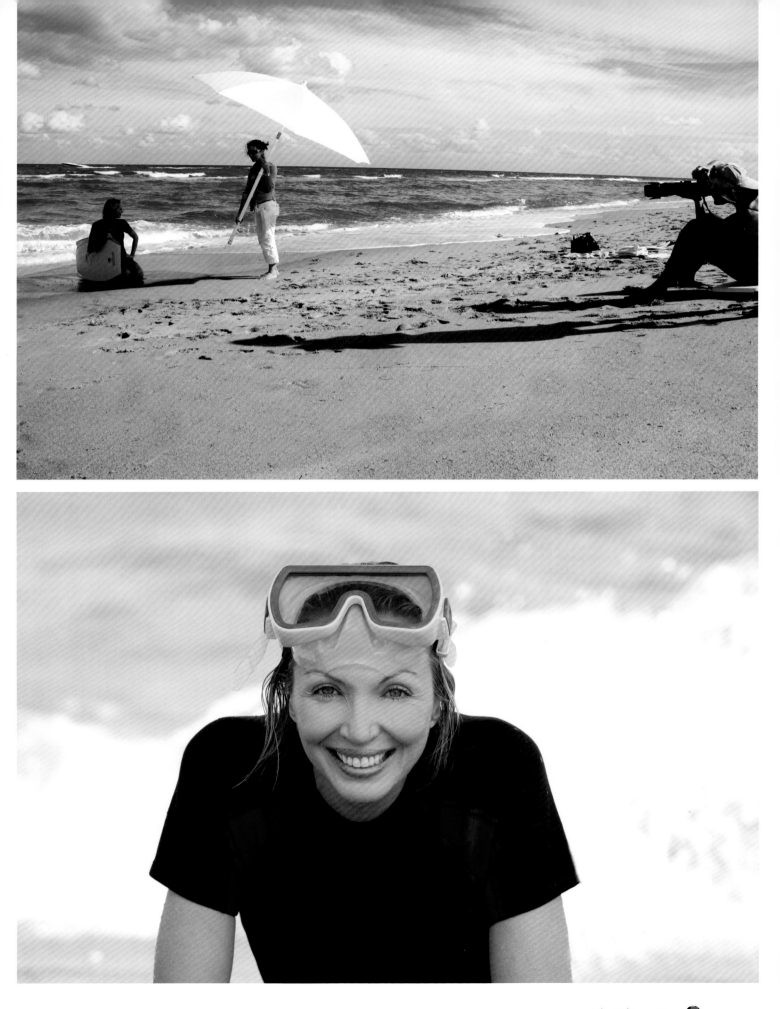

Reflectors

Flex Fills are my reflectors of choice; you can use white reflectors for unaltered light or gold-tinted ones if you want golden highlights to emphasize a late-afternoon glow. I never leave my studio without at least two of them. If you use the white side, it's a soft fill, and the silver side produces a more contrasty fill. They make a gold one for a warm look, but with digital I don't use it because we can add that in Adobe Camera Raw. The silver reflector can look like flash if the sunlight is strong and the reflector is close to the subject.

Bounce Light

I mentioned a transparent umbrella above to shoot through, but the softest light of all comes from light bounced into a reflective umbrella or off of a large white surface. The larger the bounce surface, the more it diffuses the light. This soft light is great for making anyone look wonderful.

Color Casts

It's important to remember that any diffusion or bounce device will add its hue to your pictures, which can be beneficial or not. Even bounce flash can result in an altered and unexpected color cast depending on what you're bouncing it off of. A brown or green ceiling or wall will tint the hue of any white light you bounce off of it (such as a 5500K flash), and this will be clearly visible in your pictures.

That even applies to floors, as well. For my studio floors, I installed light colored laminate wood flooring; it looked almost white. Well, unbeknownst to me, this material has a little pink in it that you can't see with the

Daylight

naked eye. I couldn't figure out why there was a slightly pink cast in my pictures, but it turned out that the flooring was the source of the color cast. I realized that when I put Plexiglas on top of the flooring or pulled the seamless background paper all the way out on to the floor, the pink cast disappeared from my images. When I discovered this, I actually did an experiment. The next time we shot, we rolled the seamless paper out and sat our subjects on that, and then we put a piece of Plexiglas down at one point on the floor and sat them on that, and we didn't have the problem with either. The Plexiglas gives you a little added reflection too, which I like, but the most important thing is that when I use the Plexiglas and place subjects on it, there's no pink. So, it was definitely the floor. The message: Color reflections from various surfaces can do funny things that you have to watch for. They aren't always negative effects—and sometimes you can even use them to your advantage—but you should at least be aware of them.

Let's say a few words about how the time of day affects your shooting. It's kind of a cliché that early in the morning and late in the day are supposed to be great times to take pictures in general, and pictures of people in particular. Personally, I'm not a big fan of shooting early in the morning, but late in the day is perfect in my opinion. I find that in the early morning, the light gets hard (contrasty) very fast, whereas in the afternoon, the light continues to get more beautiful. Indeed, it seems that as the day goes on, the more beautiful the light becomes; it lessens in intensity and gives a softer look to everything. In the late afternoon, the light couldn't be better, especially if you want the sun shining right on your subjects. Run over to your shooting location late in the day and catch the light. How can you miss? You can't. It's amazing light if it's a sunny day.

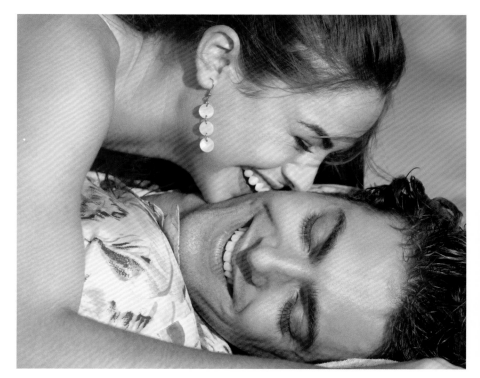

For example, I'm shooting a pumpkin patch in the late afternoon light. I have to set it up because we don't have any pumpkins here in Florida, but they do sell pumpkins at some local produce stands. So I'm constructing a big pumpkin patch for my grandkids—creating a series of pictures that look like they were shot up north. A key element is that warm afternoon light which will really make the pumpkins glow and add a pleasant hue to the kids' faces.

In the early morning, the sun starts coming up and you've got about an hour and a half to an hour and forty minutes when it's good, but as the day goes on, it gets progressively worse until it reaches its highest contrast around noon. I'm an early riser and I don't mind shooting early, but I don't necessarily like the quality of direct morning light. The morning is too rushed. You've got to hide from the sun; it's just harder. As you move towards noon, the light also becomes whiter (that is, the blue component increases), whereas afternoon light is warmer (that is, redder) to begin with and keeps moving in that direction.

When I do schedule a morning shoot, I find that I get better results by shooting in the shade—getting under a tree, a tent, an umbrella, or some other sun shelter. I just don't use direct morning light very often.

A Note on White Balance

When shooting outdoors, no matter what time of day it is, it's important to set your white balance control. Auto white balance (AWB) is a great tool; I always set my camera on AWB and then make my color and hue adjustments in Adobe Camera RAW. I an add a warm sunset look, a cool look, or a combination of the warm and slightly pink look to give the image a more appealing and salable look.

To return to my original theme—my personal transition to digital—I have to say that it's nearly impossible to overemphasize the great advantage of being able to see, look at, and evaluate the image right away. If I want to try another white balance setting, I can shoot it and view the results immediately. Not only does this enhance the learning process and help you grow as a photographer faster than ever before, but it also helps you make subjects your partners in creating compelling images because they, too, can see the pictures right away.

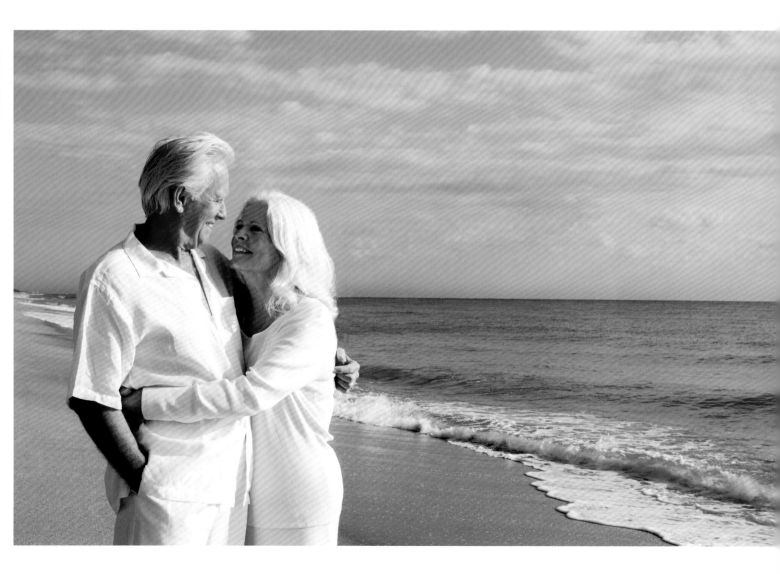

The Histogram

The histogram, which you can display on your camera's LCD screen, helps you visualize the pixel values in your image, which can be black and white or color, and evaluate the highlights and shadows in your image. When you are shooting, you can view the histogram on the back of your D-SLR to check your exposure and see if you need to adjust your lighting or exposure settings.

If you look at the histogram and see that its graph has moved to the far right, it is likely that you have blown out the highlights and

need to close down the aperture (that is, set a higher f/number), increase your shutter speed, or both. A good histogram doesn't necessarily mean you have a good picture. Sometimes you might purposely underexpose, as you would, for example, if you want to create a low-key (dark or moody) effect. In this case, the histogram graph would be shifted toward the left—toward the shadows (black pixels). When you shoot a high-key (light and bright) photo, your histogram shifts toward the right—toward the highlights (white pixels). A silhouette would have pixels

In our case, we always meter the scene and expose according to the reading. So, relying on the histogram might not be your best bet if you have a certain picture in your mind that you want to create. Keep in mind that I have been a photographer for many years, starting back in the day, when professional photographers shot mostly transparency film that has a very small exposure latitude, especially toward the overexposure side. As a result of this hard-won experience (that is, many poorly exposed transparencies!), I have developed a good eye for the kind of exposure that translates very well to digital capture (since it, too, has a somewhat smaller range than color negative film). Experience, as they say, is the best teacher.

Keep it Simple

I think the best thing a beginner photographer can do is start with the basics. Get a couple of strobes and learn everything they can do. Wireless flash set ups make studio lighting extremely easy and flexible now; no wires to trip over, quick and instant adjustments, and—most importantly—they are simple to use. Learn to bounce the light and use reflectors, and you will be well on your way to making beautiful people pictures.

distributed to both sides with few in the center, because it is naturally a high contrast type of image. A "properly" exposed image might show a majority of the pixels centered in the graph and gently sloping to either side, or it might not. The key is to look for gaps or drop offs at the edges of the histogram, and decide whether an exposure adjustment would benefit the look of your entire image.

The worst thing photographers do when they start is to over-light everything; when they could use two lights, they have five. I've seen photographers in studios light a background with six heads and then do a headshot of their subject—this is overkill. Even if you have all the equipment, you probably don't have to use it all at once. Remember this advice: Keep it simple. Start with a small lighting setup and see what you can do with bounce light, front light, backlight, and rim light. My guess is that you'll be able to achieve almost any shot you envision.

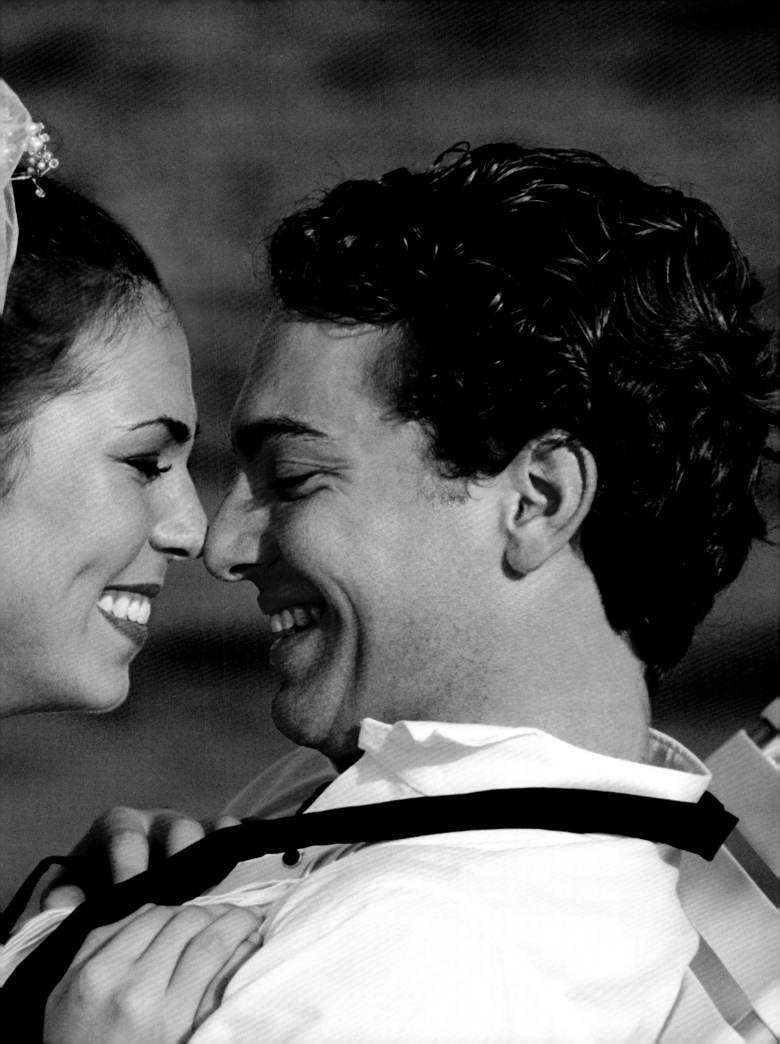

Connect With Your Subjects

My best advice for photographing people is this: You've got to have an authentic connection with the people you are photographing if you expect to create images that truly capture their personalities. In my opinion and experience, the start of that connection is a genuine liking for people. I know there must be successful professionals out there who photograph people at weddings and events, for advertising or portraits, and who don't really like people, but I have no clue as to how they make a living. They are few and far between.

I can't tell you whether having an affinity for people is something that is innate or is something that can be developed; I don't know for sure. But, I firmly believe this quality is something you have to have if you expect to consistently create people pictures that are better than snapshots and more consistent than lucky shots, or "happy accidents."

I will teach a workshop in which twenty students are shooting the same model and see vastly different photographs when we review the images. The difference I'm talking about is not the shooting angle, the lens choice, or even the lighting; I'm talking about the captured expressions, the projected feeling, the energy, and the body language. Let me give you a few things to think about when you are working with people as the subjects of your photography.

Anticipation

Anticipation and timing are crucial, and they often depend on experience and how well you know the person you're photographing. You know what your kids like to do; you know how they react, and because you know these things, you can anticipate their responses and capture the moment as it happens. Of course, there are those times when something takes you by surprise, and then you capture it because you're fast and the equipment is faster. Or, maybe you just got lucky—that works, too! The important thing is to anticipate a moment so that you are ready to capture it when it happens. Moments are fleeting and happen in the blink of an eye—literally—so stay attuned to the action on the other side of your lens when you are shooting.

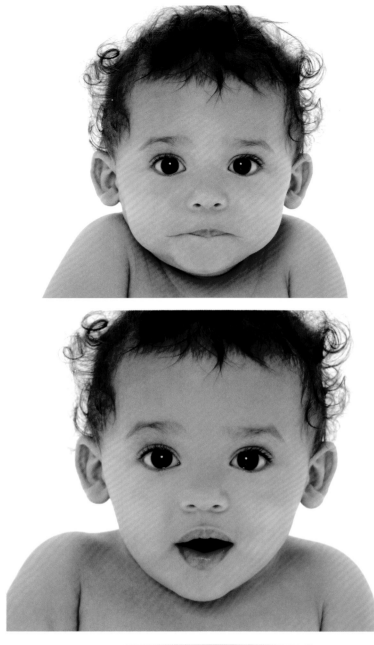

Establish Rapport

Trust

Trust is the foundation of rapport, and in order to develop trust with other people, you have to communicate with them. People want to look good in photographs, and they need to believe you're going to make them look good. I've got one big advantage in that department—a lifetime of creating photographs in which people look good. That body of work wasn't anything that I had to be coerced into producing. I can easily admit it; I like taking pretty, upbeat pictures. I like making "the beauty shot." I'm not the photographer to call if you're looking for a hard-edged, gritty, realistic look that reveals the subject in an unflattering way. The people I photograph know my work, appreciate my style, and know what to expect.

Rapport

Rapport can start with something as simple as what you say. I'm aware of the cliché of the professional photographer's constant stream of praise, instruction, and acknowledgement, but there are reasons it has become a cliché: For one thing, it holds true, and for another, it really works. I do it all the time—in fact, I never stop talking, and that goes for whether I'm photographing a professional model or my grandchild. "Great, that's it, look away. Now look over here—that's it." For my grandchild I might add, "Oh, you're going to like this one."

Feedback

My goal is to reinforce their positive feeling with my ongoing, "Oh, you look great—that's great! Now let's try this—" commentary. I don't ever minimize the importance of those comments, because before I was a photographer, I was a model. I know first hand what it feels like to be on the other side of the

camera. When I modeled, there were photographers who were naturals at that kind of rapport and there were others who weren't. When I worked for the latter, I remember thinking, "Why don't they talk to me? Why don't they tell me what's going on or what they're thinking or what they want me to do?" It was like having to play guessing games, and I don't think you get the best out of people who are guessing about what you want or what's going on.

I know that not everyone is at ease with this type of exchange. I see it all the time in my workshops. I'll be shooting, talking to the models, encouraging them, making suggestions as the students watch and hopefully learn to anticipate the models' moves as well as pick up on my methods. Then I'll come to the end of the card's capacity, turn to the students and say, "Okay, take over." And it all stops dead in its tracks because the students aren't comfortable. What they're doing is mechanical, not personal; it's process, not emotion. And when it comes to any creative art, especially photography, it is emotion that makes all the difference.

There are people you know and people you don't know. It sounds counter-intuitive but sometimes the people you don't know can be easier to photograph. Now, I know you probably won't be working with professional models that often, but the idea is the same: Respond to people; encourage them to respond to you; make your photo shoot a positive, fun experience on both sides of the camera. Your personality is going to have an enormous effect on the results.

Atmosphere

Where you shoot is important, too. Obviously, you want to be where the people are, and when you're photographing your family you have a giant advantage in that department. The kitchen, the family room, the backyard—you already know exactly where there are going to be opportunities for exciting pictures. And if you're not obtrusive and don't try to direct everyone, you're going to get the natural moments as they happen.

And, then there are times when you do want to take over and direct. You plan ahead and decide that the front of the house is the area in which you want the family to gather; or the garden will make a perfect background for some photos. Then you take over, you act like the pro photographer: "Let's go do this. Let's get the picture, it's going to be great, we want it all in the family album." Make it a quick, fun situation—it's easier if you've pre-planned it and you've seen in your mind's eye how you want the finished photograph to look. Having a clear idea of the results that you expect is another great key to successful picture taking, especially when people are involved.

A writer I know once told me about something he did at Thanksgiving. The house where the family was gathering was two blocks from a beautiful park, and on the table in the living room, way before dinner time, he placed two objects: A football and his camera. No one said anything; they just marched out the front door, took off for the park where they spent 20 or 25 joyful minutes of throwing the ball around, and snapped pictures of each other. His scheme worked because he knew his family, knew exactly what they'd like to do, and reasoned that if he just gave them the opportunity and didn't direct it, they'd all have a great time. At the end of the day, even when you have a plan, spontaneity is a vital factor when it comes to creating vibrant, natural looking pictures of people.

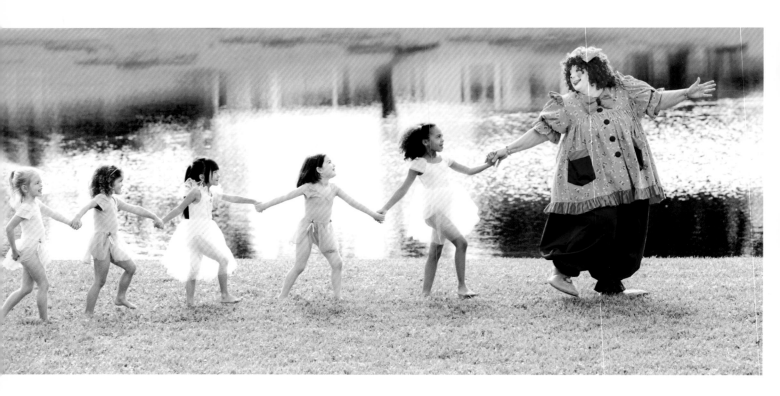

Connecting With Children

I remember a very famous photographer in Manhattan, years ago—I won't mention his name. He was a grumpy old man and frankly I don't know how he managed to get good photos of children; I know because my daughter modeled for him. However, his stylist and the people around him were very sweet. I guess it worked because everybody else on the set was nice and he would just click the camera. Nevertheless, if you're going to photograph children professionally it sure helps if you like them. I love them and they know it. It's not something you can fake—they are remarkably astute and are turned off by phoniness.

I love to work with young children—the key is to have fun and let them do their thing. You say, "Okay, let's do your dance," and they play. Older children can be more self-conscious and less forthcoming, but not always—it really depends on the child. Some of these little professional models I use are four or five years old, but they know when they come in that they're there to work, and they do their little job and they leave. You make them comfortable in the studio, and if one of them doesn't want to be on the set, you say, "Okay, go sit down a little while and draw," and they come back. This is really important when you are working with children; be aware of their energy and their signals. Let them have a bit of downtime if they need it.

When you're photographing kids, balance is extremely important. Letting them look at your camera's LCD can enhance their natural energy and enthusiasm, and it also increases their sense of personal involvement. The "Wow, take a look at what we got!" approach

is going to pay off for you in a whole variety of situations. Say your child is learning to ride a bike; you're going to take a lot of shots. You want to give her a chance to get going, to make some progress, and to give you a lot of different looks and expressions. But you're also going to want to show her what you've got. But if you interrupt the activity too often, she's going to get tired of it. For the best pictures, you have to know your subject and be able to read the situation.

When I worked with the kids in the studio for the stacked heads session, I got between 30 and 40 shots on the memory card, and then stopped and said, "Okay guys, take a break. We're going to look at this to make sure we have it and we're going to show you what we're doing." Then we started again, and they were good about it. They loved to see themselves. Make no mistake, kids these days are quite accustomed to seeing themselves and everything else in their world on LCD screens, computer monitors, and TVs; they'll probably get right into it.

Parents are great assets on a shoot because they're usually familiar with the personalities of their own kids, and can clue you in to what kind of pictures their kids can make best. That's why it's always a good idea to talk with the parents first, especially when dealing with very young kids. Often they can help you to set up situations that work better and suit their kids' personalities, and to avoid potential pitfalls because they know their own kids better than you do. They're also highly motivated to do so because they want to get the best possible pictures of their kids. As a photographer, you may have a great idea in your mind of how a kid should look or what they should be doing in front of the camera, but if you're trying to force a round peg into a square hole, you're not going to get the best poses, or you're not going get

the spontaneity that is the essential element in almost all great pictures of people. Meet with the parents ahead of time and get an idea of what the kids like to do; this will steer you in the right direction from the start.

If you round up your kids and their friends and say, "We're going to take pictures now," chances are you're not going to get very good pictures. A better approach is to eliminate the preamble and just go ahead and do it. In other words, don't make a big production out of it. Kids want to do what they want to do, and if you photograph them as they go about doing this and that, you're going to get animated, natural-looking photographs. The age of the kids and their corresponding attention spans is going to be an important factor, too. Here's where a timely break in the action to show them what kind of shots you're getting can be really important.

Whoever your subjects are, you have to be aware of where they are—you need to be attuned to their state of mind. With kids, the most effective strategy is to move them in quickly, not to linger, and to shoot while they're fresh. Don't take a million test shots—dispense with the preliminaries and just start shooting. Most kids are pretty good in the beginning, and they'll hang in there until they just get tired of doing it. And then they'll often tell you (or show you) that they're tired of doing it. Kids are very direct, not like grown-ups. So you have to employ new tactics. Give them a break. Or tell them they can't be in the next shot; use a little reverse psychology. Say, "Oh, we'll use the other child." Then they'll say, "Oh, no, no, no, I want to do it!"

Here's a good example of the kind of balance between shooting, looking, and motivation that occurred just the other day in my studio. We had all the kids exuberantly jumping and I shot a full high-capacity memory card, around 40 to 50 images. Then we had to pause to download the images to make sure we had nailed it because this was a commercial assignment! Well, we got it, but the kids were so enthusiastic that we had the kids jumping all over the place. Then we put all the images up on the screen, and I showed the kids how great they looked jumping. I said, "We're finished with jumping. Now, we're gonna stack your heads up in a row!" That was a completely different shot, but the kids were motivated because they could see what the jumping looked like and could show the pictures to their mothers. We didn't stop in the middle of the card and go over to look. We finished the card and we said "Everybody take a break." Then we loaded the images to the computer so we could all see that we really got it and what it looked like. If we hadn't captured what I wanted, I would've said, "Okay, back on the set; let's do some more." Instead, we were able to show them that we had gotten it and move to the next thing. That's nice. The mothers love to see it, and the kids love to see it.

Recognize the Saturation Point

There comes a point where the novelty wears off, with adult models as well as kids. They get tired or their motivation flags. Last week we were shooting on location in a house and had these laptops set up to view the images. During the first shoot scenes with the models, they would come over and eagerly look over our shoulders to see what we got. After a while, they'd be talking among themselves

and doing their own thing. So, to maintain their interest I'd say, "Come look at this—it really looks good." So they'd come over and look at it, but after a while, it was clear that the novelty was wearing off. Or, at times they didn't like the way they looked. Models, whether professional or amateur, can be very funny—I'm sure some of them don't ever like the way they look, even when the general consensus is that it's a great shot.

At some point, what started out being an exciting, creative interaction can become a chore. Or as I put it, even when it starts out as fun, it's work when you're not getting what you're trying to get. At this point, it helps to step back and evaluate the situation and figure out what the heck you have to do to get it back on track. You know, sometimes it works immediately, which is absolutely wonderful, but kids can be difficult, because sometimes when they get cranky, there's no going back. They get tired and either say or act like, "I don't want to do this anymore. That's enough."

Tuning in to the dynamics of social interaction is an important skill for portrait photographers to develop. That's because you can take better pictures more efficiently by understanding or tuning in to how families and kids and their siblings interact, or figuring out which kid wants to be the center of attention. Many times, these things become very apparent even to a casual observer. You can tell when one kid gets annoyed or another one gets antsy in certain situations. You can pick these things out, and more importantly, you can actually use them to your advantage if you're alert and aware.

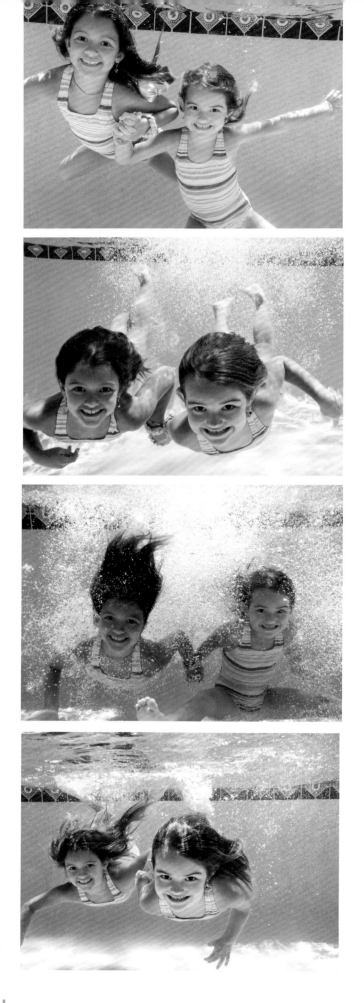

Discovering Beauty

People often ask me whether or not it's true that some people are just naturally photogenic, the camera loves them, and others, even those who look great in person, just don't translate into good pictures. Well, with the exception of my two granddaughters, I use professional models whose pictures I've seen and liked. However, I don't think there's any formula for being photogenic, and I'm often surprised at what happens.

I'm so lucky that my granddaughters are photogenic and full of personality—that is what I try to capture. They are so comfortable with me photographing them because it always becomes a fun time. They are such little fish in the water, and have quickly become my best underwater subjects.

The bottom line is that you can't dismiss somebody as a potential model just because they're not physically perfect. Having said all that, I'm sometimes surprised at how good someone will come out, and we'll all say, "Oh, look, that's great." Some people are just photogenic, yet it cuts both ways. I've known some cases of people who are just beautiful in person, yet the camera for some reason doesn't do them justice, and others who look nothing more than okay, but just come alive in photos.

I remember looking at the screen recently when my Photoshop specialist Safaa was retouching some photos of this girl who is reasonably attractive in person, but when she's smiling in photographs, her eyes just light up. She looks even better in photographs than she does in person! So that's a plus. But discovering these attributes and positive and negative characteristics is a process.

You've got to take the pictures because only then will you learn who in your family or who in your neighborhood or whatever, will be a good subject. And that happens, believe me, it's the ballgame. That's why for years I've used the same models over and over until we get tired of each other, because when one clicks with you, and they do have that quality, you've got to hang onto them.

Of course, part of that process for any serious or professional photographer is to keep exploring, keep finding new people. When it clicks, you can tell the instant you see the photos. Recently, I found such an exciting new model and it really made my day. As a bonus, she's a real pleasure to work with. I know she's going to be great because she wants more photos of herself to help establish her career.

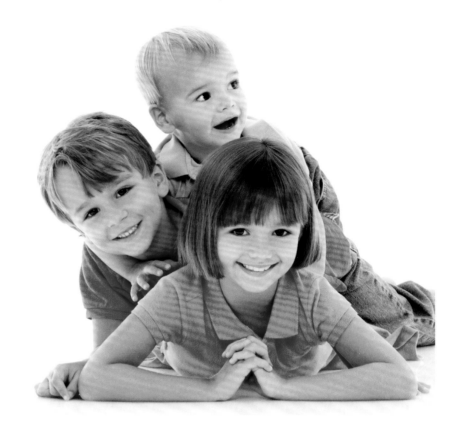

Image Review

Let me say it right now: Digital technology is better than film when it comes to photographing people. This is not only because digital images are now superior in terms of quality, but also because digital capture offers a host of operational advantages; the most important—especially when photographing people—is the instant image review on the LCD monitor.

But there is a downside to this benefit—something I first noticed as digital started to take over professional photography. I was teaching a workshop (I was still shooting film at this point), and conducting a shooting session on a beach with models dressed as a bride and groom. I had been talking with the workshop students about the concept of going for the "moment"—that indefinable instant when something really good starts to happen among the people you're photographing. It often takes some time for that kind of interplay to develop, even between models, but when it happens you're going to get the magical pictures.

I noticed that the workshop students who were shooting digital would take a few frames and then stop, while the film shooters among us just kept on going, kept shooting. The models were running along the beach and jumping around; the groom picked up the bride and ran to the water's edge and then into the water a bit. Things were really happening, and the digital shooters were missing it because they were busy looking at their cameras' LCDs to see what they had just taken. This repeated itself in several setups and situations throughout the workshop. The digital gang would grab a few frames, stop, and look; take a few more frames, stop, and look. I felt like yelling at them, "Just shoot the whole card!" Eventually, I did tell them they had to treat the memory card like a roll of film if they expected to get great shots.

This is one problem with digital photography that is totally avoidable, and you'll see it everywhere, among professionals as well as enthusiasts and beginners. The pros call it "chimping"—that quick up and down head bob (like a chimpanzee) as the photographer checks the LCD after every shot to see what he or she has.

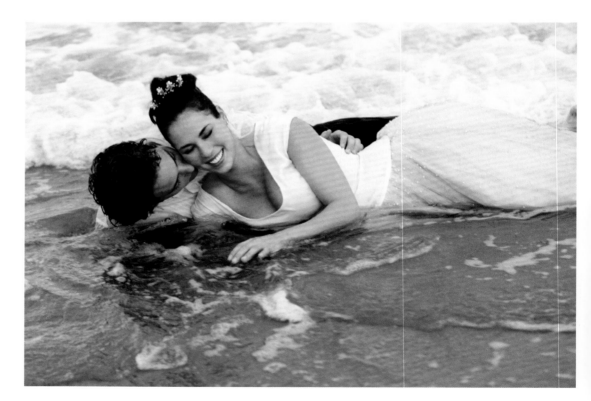

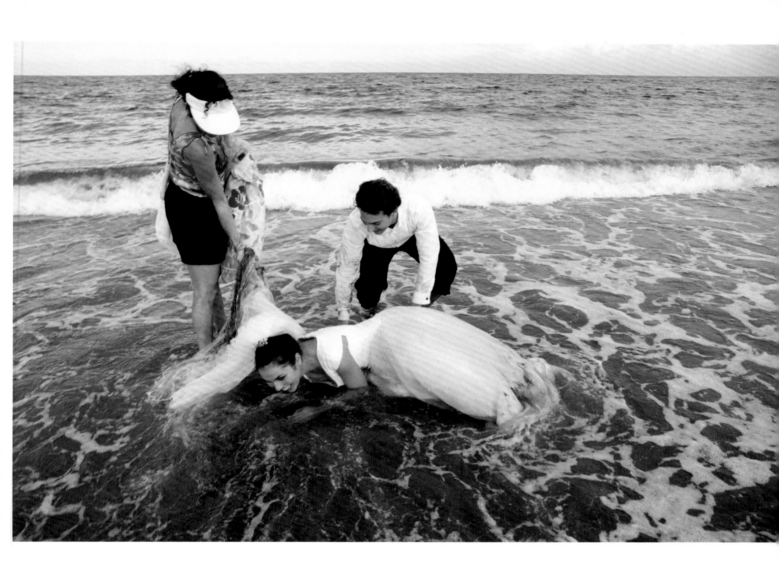

I can only imagine what would happen if I did that when working with models. Imagine if they were just getting into the mood of the scene, the feeling of the shot, and I pulled them up short and said, "Hold it, I got to check what I've got here." Well, that's exactly what happens in many studios and on location these days, and when it does the energy level just drops away. Just when the photographers were getting to the point of getting something really good going, everything stops.

At the end of the workshop day, many of the students were wondering why they'd captured so few of the magic moments that occurred between the professional models whose job, after all, was to give them those moments. In fact, I told them why they missed so many of those key moments, "While the models were running into the water and doing great things, you were busy looking at the backs of your cameras."

Don't let this happen to you. Even if you aren't working with professional models, you'll lose the moment just the same. The strongest advice I can give you is this: Don't stop the moment when the moment is happening. As they said back in the '60s, go with the flow.

There is a balance here, of course. When I check to see what I've gotten during a shoot in my studio, I do it during a break. Overall, I tend not to look at my images until I'm done with the card, but you may not be taking that many pictures. The key is to find the right time within the session or suitable circumstances to see what you've captured. For me, people photography is all about establishing rapport, and that takes time and effort. I'm not going to make it harder by interrupting the flow once I've got it going.

Inspiration & Style

④

Inspiration

What exactly is it that inspires your creativity? It may be hard to define, but it comes from everywhere. It comes from the people you know and the things they like to do, from local events, celebrations, and parties, from your own imagination, from photographic techniques themselves (like the blur or freeze frame of people in motion, or faces defined by light and shadow), from props and clothes, from hobbies, interests and lifestyles. Inspiration comes from all of these things and more, and it takes form in a lot of different ways as you respond with your camera to spontaneous opportunities or plan and execute creative moments.

There's no doubt that photographing people is something I like to do because they were my first inspirations when I got into photography—they are the most interesting, thoughtful, and challenging of all photographic subjects. There were other things that attracted my attention—the scenes I saw in movies, the layouts I liked in magazines—but people were my central motivators. I wanted

to work with them, see what I could dream up for them in terms of themes, sets, locations, props, clothing—everything.

I recently saw a model on the cover of a fitness magazine and thought, "I'd like to work with her." I found out from her agency that she lives nearby so I booked her first for a workshop session, then for a session for myself. I'm going to build a whole lifestyle stock shoot around her, complete with other models, including my granddaughter. And this is all because she's just amazing looking and I'm sure she's going to spark some imaginative photographs. I'm already thinking of situations I can set up using her as the central subject—a bridal outfit, a family fitness workout, picking and arranging flowers.

Sometimes inspiration comes from clothing. A while back, I noticed a bunch of cute little ballet dresses hanging in a store window. I immediately went in and bought them and put them away because I knew that eventually I would get the right kids for those outfits.

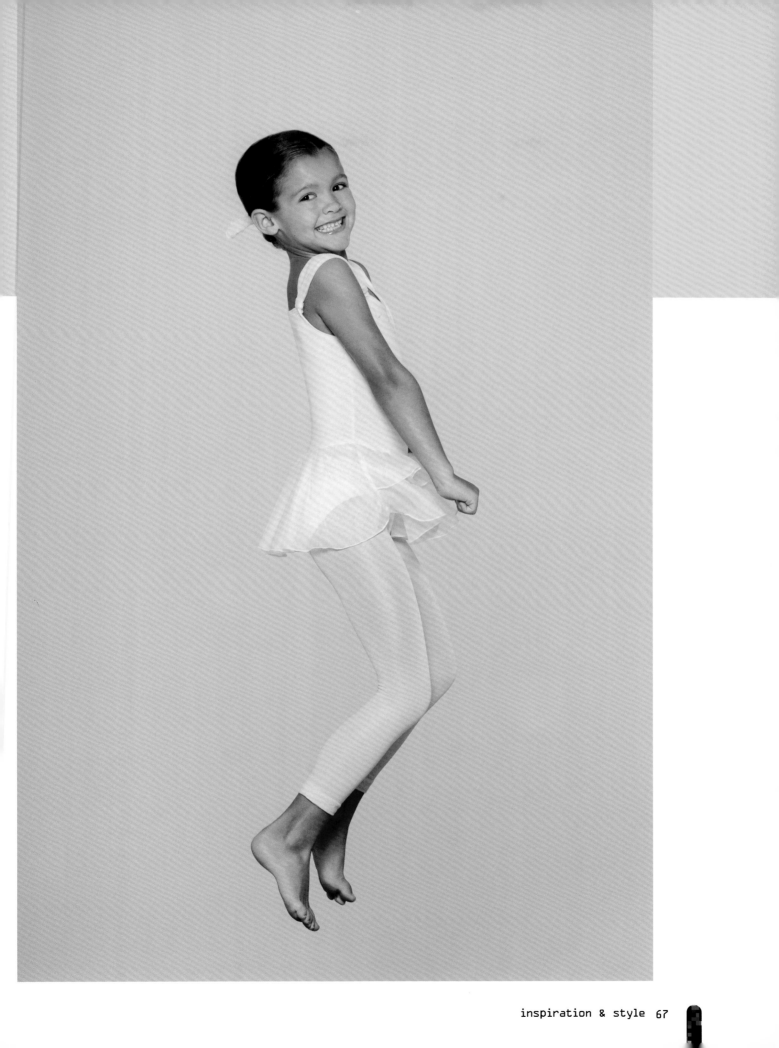

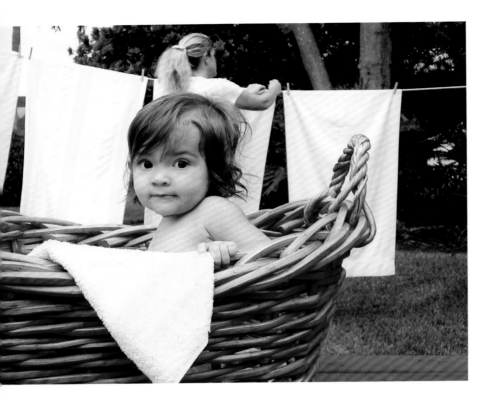

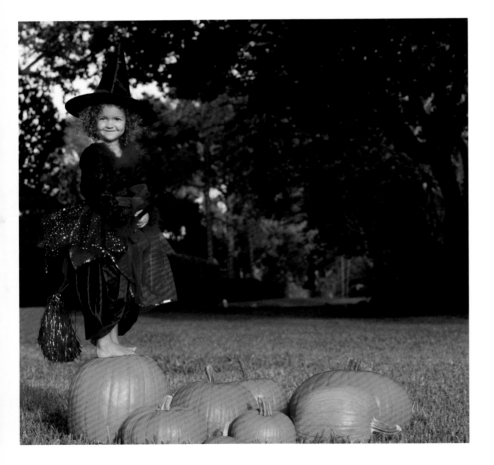

Props also inspire me. As I was driving by a huge pumpkin patch last fall, I stopped in my tracks, turned my car around, went in and bought ten beautiful pumpkins. Within a few days, I had shot some really engaging pictures of my granddaughter playing with and crawling around among the pumpkins. A few years ago I used a laundry basket as a prop for some photos of her. I put her in the basket—she was so little then—and I positioned her mom in the background hanging up clothes on the line. So, the inspiration there was nothing exotic, nothing unusual—just a laundry basket—but the result was an iconic image that has a Norman Rockwell feel.

Sometimes, even a great background can be a source of inspiration—like a wonderful, ornate door or simply a window with a great view. Put a person in the scene and you've got the setting for a memorable photograph. Inspiration can come from the seasons of the year. I'm based in Florida, but a few years ago, I spent an autumn day in Connecticut photographing kids while they played in the leaves. The only prop I had was a wheelbarrow unless you count the colorful leaves. If you're located where the different seasons bring about visual changes in the landscape, you've got the opportunity to use the same location at least four times a year—maybe more—to create the kind of variations that often wind up on one of the zillions of pictorial calendars published each year.

None of this has to be complicated or take a long time; just see what grabs your attention. Start with an idea, work with it, and see where it goes. Just remember to always take advantage of what's available, and always be looking for what's out there. Someone once said that genius is 1% inspiration and 99% perspiration, but I don't completely agree. When it comes to digital pictures of people, what you really need—in addition to good technique—is to have a visual mindset and always be open to inspiration when opportunity knocks.

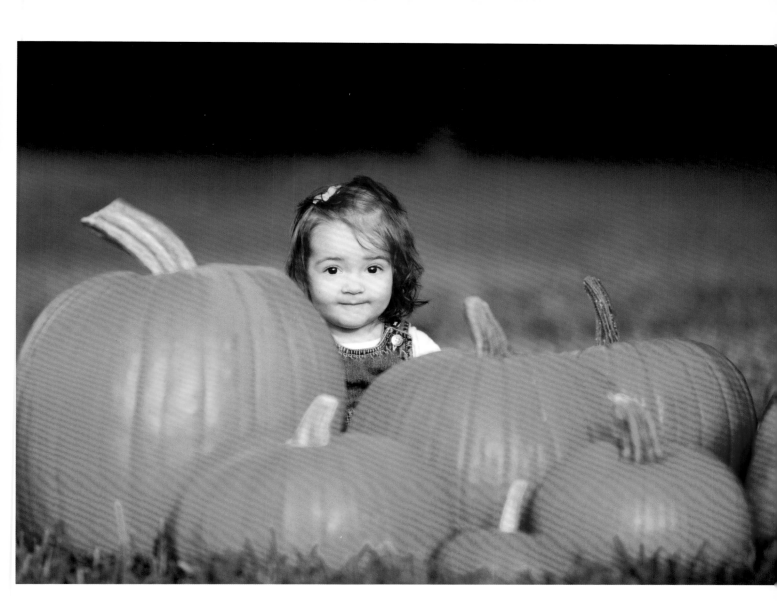

Elements of Style

The Look

A personal style is a great thing to aspire to, but it can be a hard concept to define—you can't really put your finger on it. However, that doesn't mean that it isn't very real. Even if you can't define style, you can say some useful things about it. For example, it starts with the kind of pictures you like to take, what you're good at, and what you enjoy looking at. These elements really constitute your "style guide."

Technical Skill

Photographing people with a D-SLR requires a certain amount of technical understanding of the medium if you expect to operate at a professional level, but having the right attitude and developing a personal style is even more important. You have to take pictures that make you and your subjects happy. At a workshop I gave recently, there was this really sincere and intelligent student, but with different priorities. After talking with him for a few minutes, it became clear that he wanted me to show him how to use grids for

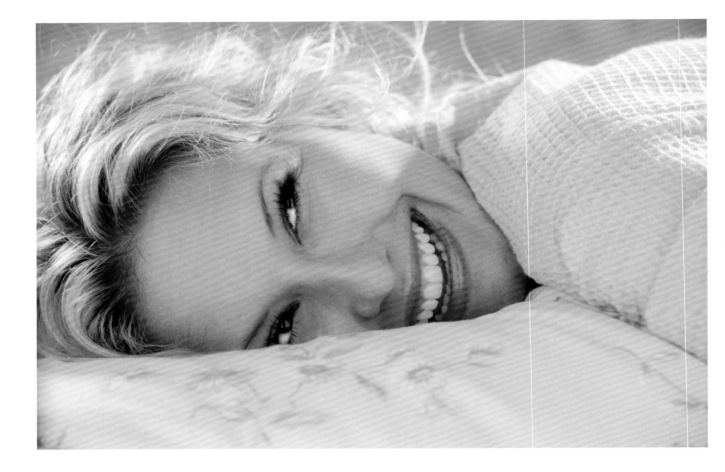

Connect with the Subject

composing pictures, how to do this physical fitness thing, lighting bodies using side light, etc. The end result would have been a lesson learned in lighting, and that's a good approach to certain kinds of photos. I definitely could have shown him how to make them, but those are not the kind of photos I love to make. And it's also why I'm not the right teacher to present a bunch of assorted lighting equipment and show how to use it to create this or that effect. It's not that these things aren't important; it's just that other things are even more important and should come first.

When I'm creating the kind of pictures I really love to make, I like to catch the intensity of the moment with the person. To be honest, that tends to be when my subject is animated and happy—you know, when a child is really jumping, a woman is really laughing, or a man and woman are really hugging. I generally try to capture a moment of joy and happiness as opposed to the other side—sadness or whatever. I definitely go for the joyous moments, and that's something you have to work at. That's what I prefer, and for my style of photography, responsiveness and empathy are much more important than the technical stuff. If I have to do the opposite and create moody or downcast images for a specific assignment, fine. For a while, the agencies were on this kick where they wanted us to

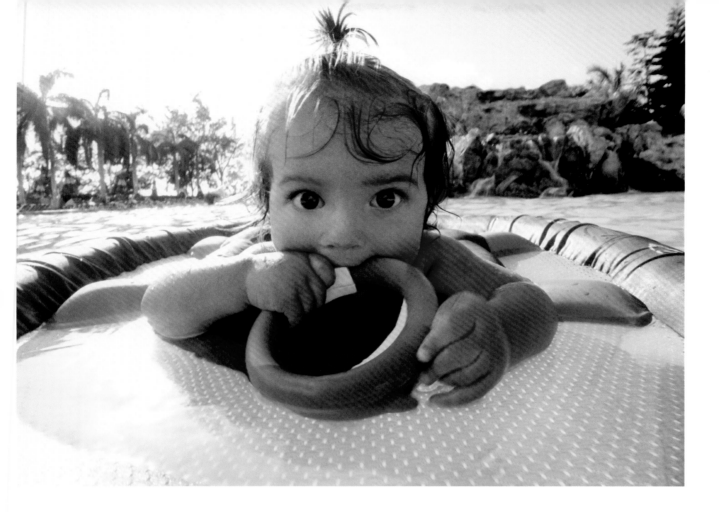

Develop a Personal Style

show negative, show frowning, show anger and all that, but it's just not me, and I think being yourself is essential. Even on the few occasions when I successfully created "unhappy" images for commercial purposes, they were never the ones I particularly loved to shoot. I would cover the assignment, but that's not where the photos started—I would begin on a much happier note in order to establish a good relationship with the subject.

In short, if you expect to satisfy yourself as a serious enthusiast, semi-pro, or professional photographer you have to start by asking yourself two key questions at the very beginning: "What kind of pictures do I like to take?" and, "What kind of pictures do I like to look at?"

My general advice, which applies to any photographic genre: Don't try to copy every single thing you see. For example, I admire the work of Richard Avedon very much, but I can't copy Avedon's portraits because I'm not him and that's not my style. That's why the most useful thing I tell other photographers is this: You have to find out what your own style is, and that happens when you shoot all the time. Only then can you eliminate what you don't want to shoot and hone in on things you are good at and enjoy. That doesn't mean you can't have a variety of styles— just because you love to go to the Everglades and shoot birds doesn't mean you can't shoot great photos of your family. There's probably an area where you're strongest and it's crucial to find out what that is.

Keep It Simple

The process of elimination is a good guide to follow to find the heart of your personal style. You may start out by determining what it is you like to shoot, but then you have to kind of refine the process by weeding out what you don't like. When most people first pick up a camera with the intention of creating something more meaningful than snapshots, they typically shoot everything in sight. There is nothing wrong with doing this as a process of self-discovery, but then there's the second step—going over your images thoughtfully, looking at what you've got, and determining what it is you really like to shoot and what you enjoy doing. It doesn't matter what art form you're talking about, anyone that does too many things generally doesn't do any one really well. So, if you're serious about photography and want to become a professional or supplement your income by selling your pictures, you've got to develop a style—some kind of style that really suits your interest and temperament, a style that your clients or whatever will recognize. That's hard—frankly, it can take years—but the results are extremely rewarding, both personally and financially.

Stick With It

Nowadays, there are a lot of freaky style trends out there, and they've been around for a while because many photographers continue to equate being different with the essence of creativity. One cutting edge trend is what I call weird photography, almost to the point of being actively ugly, in my opinion. In some circles that approach is really "in." And if that's how certain people see the world, well good, more power to them. I don't—I've never tried to do what they call edgy or

cutting-edge photography—it's not my style. I see my style as perhaps more generic, but it is also more enduring—it will always be there. No matter what happens it's not going to go away. In the meantime, styles come and they go, but I keep my style and I suggest you do the same.

My Personal Style

There are aspects of my style—like light, for example—that I use to define my own style. People are always telling me, "Oh, you like clean photos." Yes, I do. "And you seem to use a lot of white and lightness." Yes, I do. If I can choose between shooting something light and shooting something dark, I go light. If I can opt for an available light studio, I'll do it because I'm getting a lot of high-key light, and that's what I like. What's interesting is that my "light fixation" also extends to

backgrounds and props and things. For me, everything has to blend into that kind of light color tone. The vast majority of my work consists of white, bright backgrounds and light colors.

When I think of all the things I asked my models to bring to our next shoot, it's the same—they're bringing whites, beiges, and maybe some light grays. I don't want any dark colors—it's not my style so I stay away from it. I'll bring flowers that are colorful and have a few brightly colored props the

kids might play with, and maybe one of their dresses might be a pastel color, but these are really accent colors—the main theme is lightness, light colors, and a lighthearted mood.

In a sense, all of the elements that comprise a personal style become kind of like a signature. I wouldn't go as far as to say that people constantly run across my work and say, "Oh, that must be a Nancy Brown photo," but it is my style. Ultimately, whatever you do the most of becomes your de facto style.

It's interesting, because a lot of us shoot in a similar way and I don't really know what makes my work totally different from somebody else's. I mean, you can obviously tell the minute you see an Avedon shot or an Irving Penn shot, no question. When you see one of mine you might say, "Uh, is this Nancy or is this so-and-so?" In other words, my style is not as distinct, but it might have a little combination of visual elements and

mood that clue someone in who is really familiar with my work. Having this level of identifiable style is something that you can aspire to and it is sure to serve you well if you expect to sell your work and see it published, no matter what particular photographic genre you choose to specialize in.

If you're a creative spirit that can't be typecast, you'll inevitably shoot something every now and then that'll really shock your viewers. It may be totally different and that's something you should accept because it may open up new opportunities even if it's not your norm. A good example of this kind of scenario is what happened on the China trip I just returned from. Basically, I took loads of satisfying pictures of wide-open spaces, spectacular scenic views, and little kids' faces, but if I ran these by you, you might say, "Nice travel stuff, but that's not what you usually do." But in that amazing country, how can you resist? I didn't have a model so it was a different way of working—and I loved it. The message: Don't get so stuck in your style that you can't respond to new things with passion and sheer enjoyment.

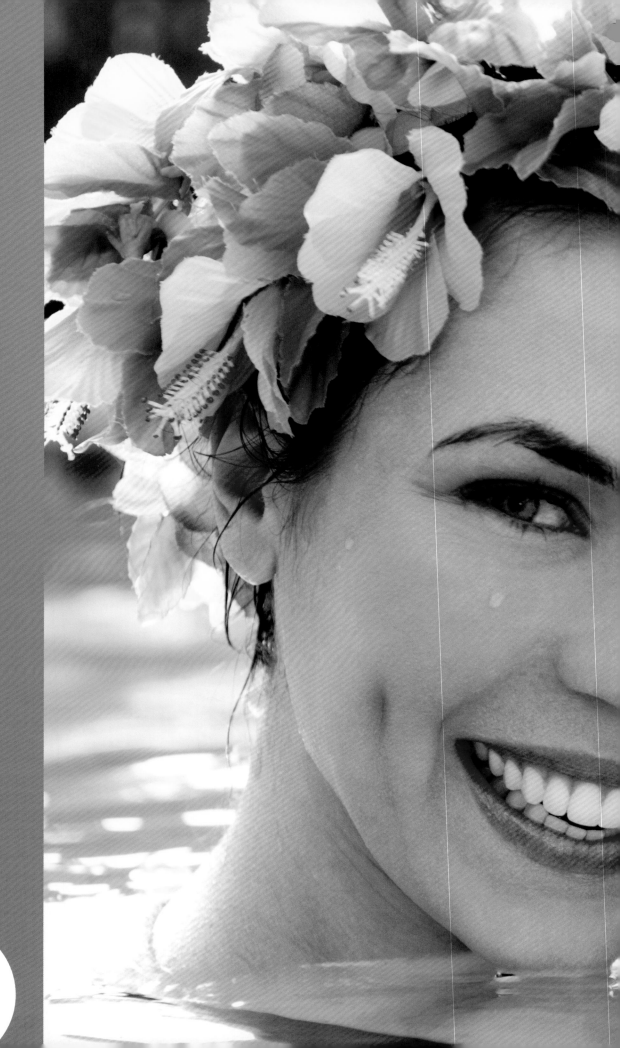

Setting Up a Shoot

⑤

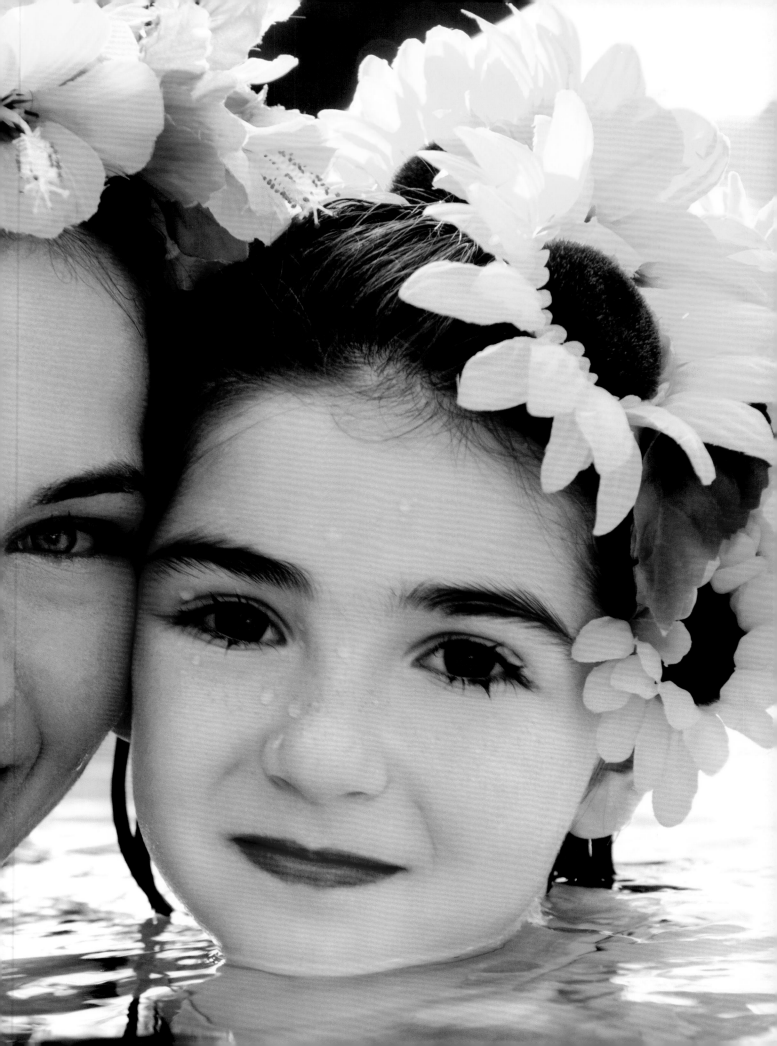

Organization and Flexibility

The most important thing to keep in mind when you are planning a shoot—whether it is for stock or business or a day at the park with your family—is to be organized. The more you plan in advance, the more you will get from the shoot, and the better your final images will be. The message: If you want to take consistently great people pictures, by all means have a structure, have a theme, have a plan, have great props, location, and lighting, but always, always be ready to go with the flow. Even the best-laid plans can go awry, but if you stay flexible and open-minded, you will always have another option.

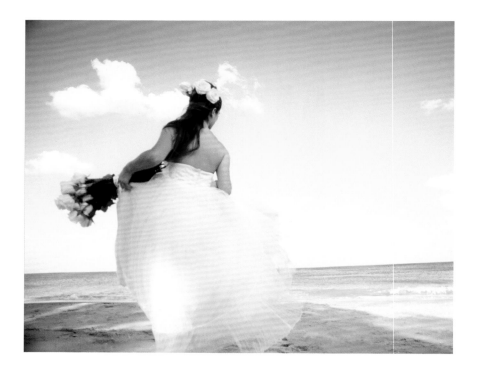

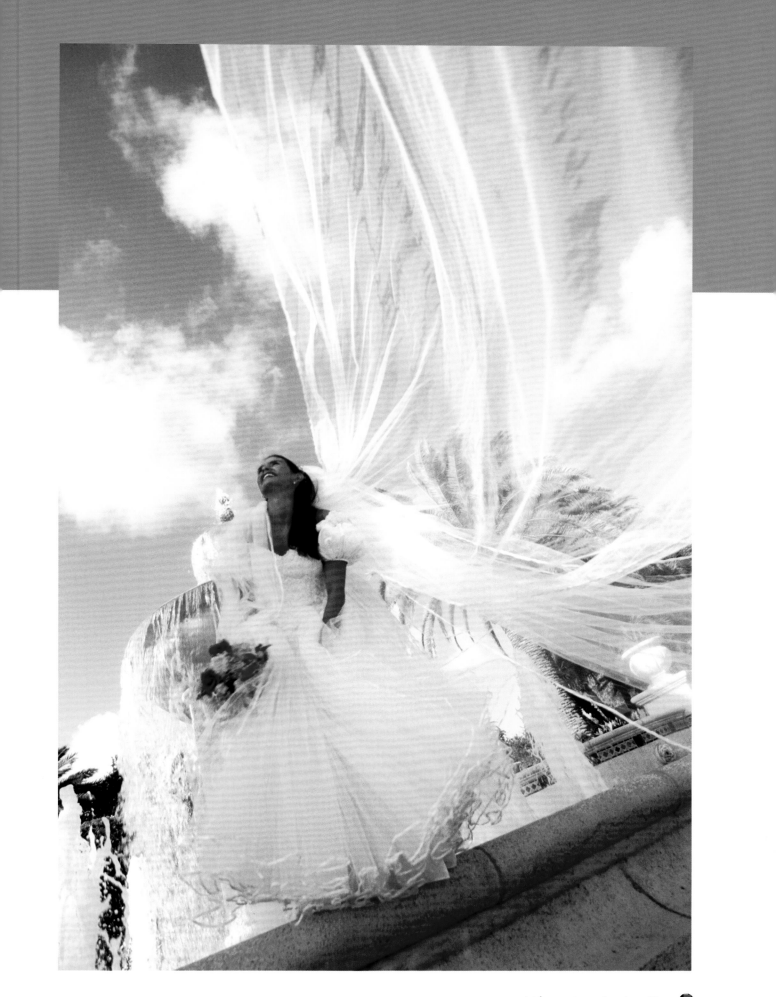

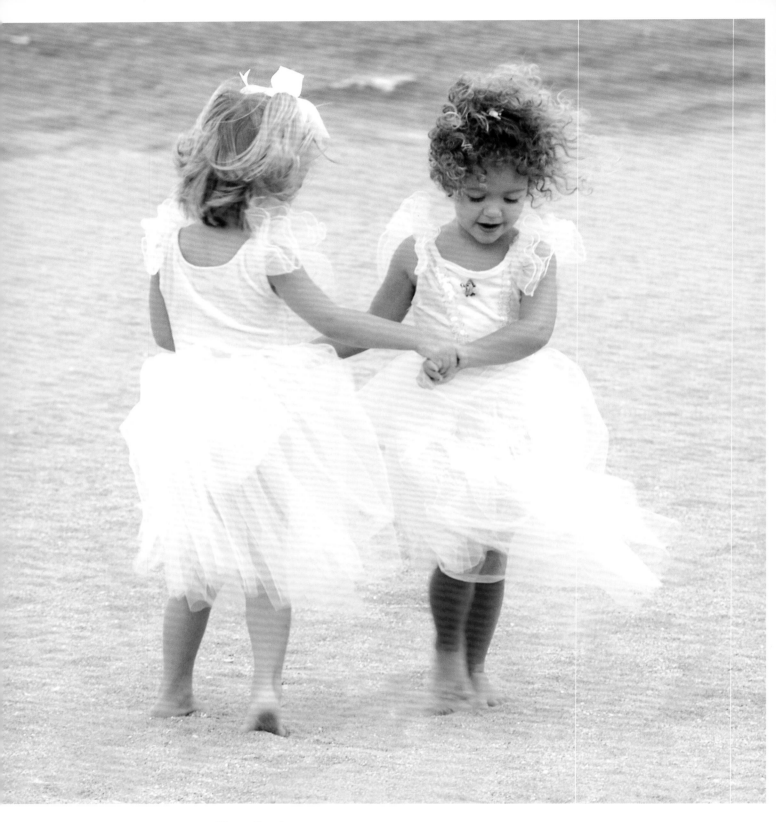

Envision a Theme

A good way to approach a shoot is to envision a theme. It can be a broad idea based on the subject or a specific technique, such as people in motion, the play of light and shadow on faces, or various moods. However, I often take a situational approach in the sense that I will create a theme by selecting subjects, their attire, and an inspiring location, and then just let things happen.

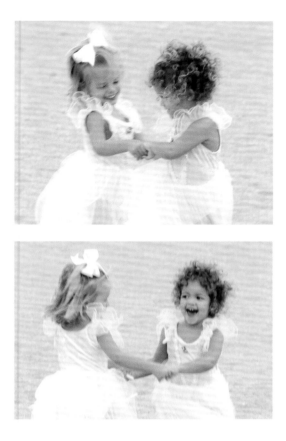

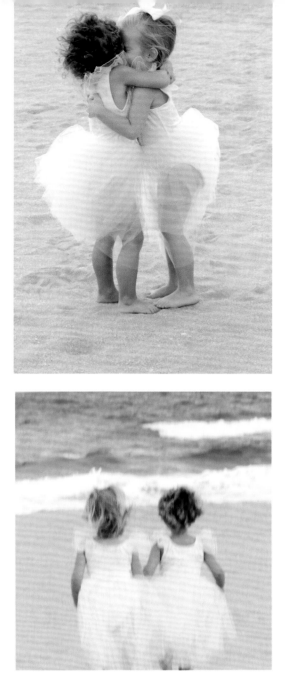

I took my granddaughter Hailey and her cousin Sally, dressed them in very light pink little tutu dresses, and I took them to the beach. We worked and played on the beach for a number of hours and I had them hugging each other, running, and skipping. This wasn't just freeform activity—I had a goal in mind. I wanted it to look kind of like a dream-like fantasy, so some of the images are blurred and others are out of focus as they're walking away from me.

I also had a clear idea of the end product I wanted to create with these images: Little print-on-demand photo books to send out as Christmas gifts for the family. Knowing how I ultimately wanted to use the images really helped to structure the whole concept because I had a clear idea of what kind of images would work best for the gift books. This is a good example of how you can start out with an idea and end up with a final product, but it also illustrates the basic parameters of a themed photo shoot. It started out kind of unstructured and random—a lot of things were fuzzy and moving. After that, it was all about mood—two little girls that love each other were having a great time for a couple of hours in their own little world. I didn't want it to look like I was even there. They were just doing

little girl things, playing games, running, laughing, and having a ball. I was just in the background, shooting away with my camera. They weren't posing—this wasn't supposed to be a "look at me" time—and that's why my little books capture the joy of Christmas even without the snow.

It is really important to be open to the things that you see in everyday life when thinking about and planning a themed shoot. Even commonplace things can suggest ideas for pictures if you keep an open mind and constantly think in visual terms.

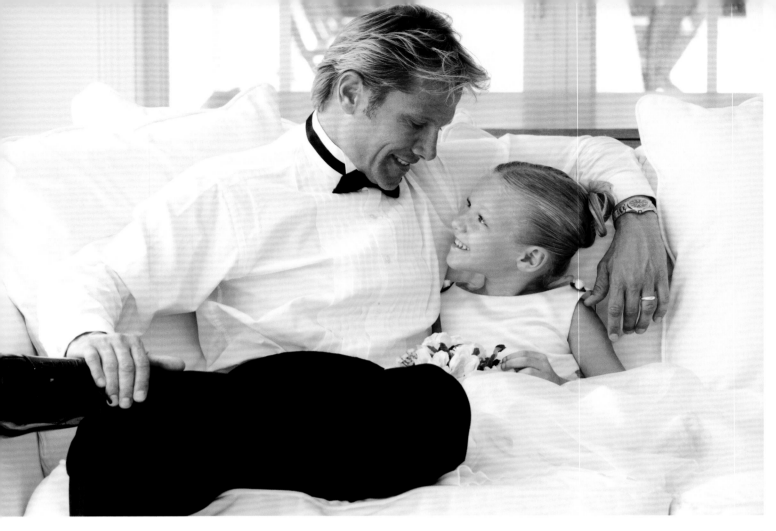

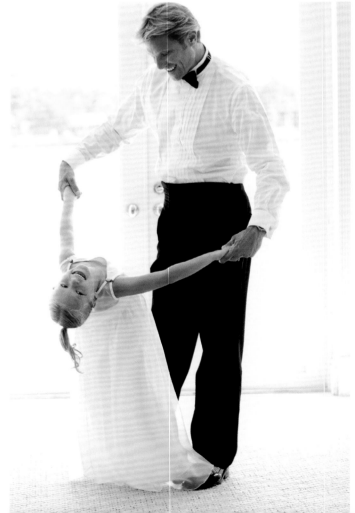

Be (Extra) Prepared

That's really the key—you have to plan it. When I went to the beach with Hailey and Sally, we had buckets, shovels, and sieves; we had all that stuff, but we didn't use it because I kind of wanted them doing nothing—just playing with each other. Even though I knew what look I wanted—just the two girls playing together—I had other things available in case they got antsy. You have to have a backup plan, even if it's something as simple as, "Oh, let's fly a kite," or, "Here's a bucket, let's play in the sand." We had props, like a blanket they could sit on (thank heavens). You don't go without things like this, because despite your most elaborate plans, you never know what's going to happen. You have to have things at the ready.

When you're planning a themed shoot, you should think, "What's the ideal thing that could happen? What would I love to have happen?" Then make sure to bring at least the things you need and try to make it happen. If it doesn't happen or things move in a different direction, don't force it, but have a backup idea in mind so that you can say, "Well, if I can get them to do this, and the weather's right, great. If not, I can at least bring the right props." Then, at least you've taken care of the things that you do have control over. Be ready for anything. And for the sake of your own sanity and of those working with you, don't get bent out of shape if all of a sudden they don't want to do what you want them to do. That's why you have your alternate plans. Yes, you want to come home with the photos you envisioned, but something even better may happen when you're behind the camera and letting things follow their own course. So, I try

to visualize what I'm going to do with these two little girls, maybe playing or kissing each other, or whatever. But, in the end, I'm going just to put them in there with my ideas and see what they actually do. For me, the keys for a successful shoot are planning, flexibility, and control, but not being a control freak.

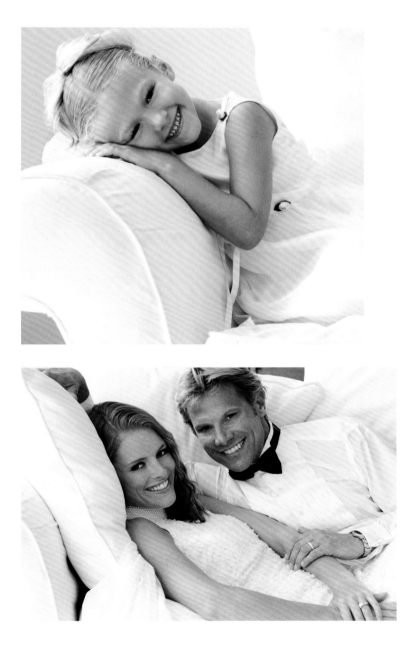

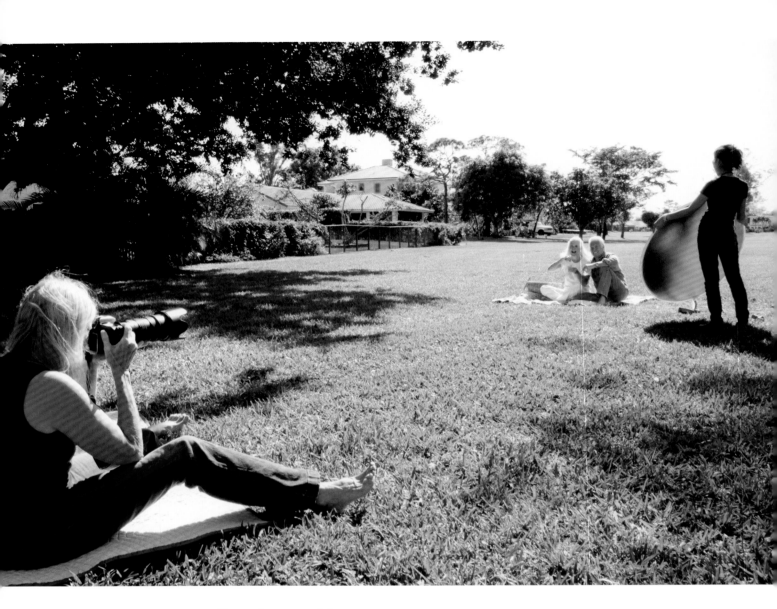

On Location

If I'm envisioning a shoot on location, I'll scout the location in advance so I know what I'm dealing with. I look for things like where the light hits during different parts of the day and where it is coming from, the elements available at the location, and how many different set-ups I can get out of one location.

Looking out a back window of my daughter's house, there's a great view of this big, sun-soaked yard and you can tell that it is a great place for taking people pictures.

Photographers should be aware of the location of any nearby parks and where the light comes in at various times of day, so you'll know when and where you'll get the kind of lighting you want. You wouldn't go out there at noon, for example, just because it's a pleasant location; you'd wait until it's the end of the day, when the light comes through the trees. You should have a list of places where you take people. The beach is almost always great, but even there, it is easier to shoot on overcast days, in the early morning, or late in the afternoon when the light isn't so harsh. Whatever you do, make sure you see places before you schedule a shoot there. Go check them out to see the lay of the land and avoid unpleasant surprises.

Lighting on Location

Working on location does impose certain limits. For one, you don't have complete control over the light, so you must plan in advance. As with my approach to photography in general, I keep my location lighting as simple as possible.

I've mentioned that I like to work in the afternoon, from about 3:30 P.M. until sunset—there's not a soul in the world who looks bad in that soft, diffused light—but I can't always plan my shooting around late afternoon light. So, to deal with this, I'll shoot early in the morning until the light gets too harsh, and then I'll begin working with umbrellas, reflectors, and the white nylon in order to control the light as best as I can.

You have to be able to outthink the light; I've found I can get away with noontime light if I'm shooting down from a high angle with the model right below me. With the sun directly above, I can get a nice look to the image.

Props on Location

Sometimes a photograph—or an entire shoot, for that matter—can be completely inspired by a single element. I went on location to Prague once, and the entire trip was based on a prop. It was an article of clothing—a cape. I had shot an image of a girl in a cape at one time, and I liked the outcome, so I pursued the idea again with a different model and in a different location to see how far I could take it this time. The whole shoot started with that one element.

Any location will have its own set of suitable props that goes with the setting. If you are shooting in a public park, there are most likely benches, trees, and swings at your disposal. If you plan in advance, you can bring things to supplement this vision: A picnic basket, a blanket—anything that achieves the look you are going for.

If you're going to the beach, take a nice looking beach chair and sit someone in it. You need predictable things that you can rely on. I always keep a bunch of hats in the car. Hats are neat props, and it is nice to work with certain things that you're familiar with. Hats are good visual accents and kids love to play with them. A nice hat can really enhance a headshot. I'm always on the prowl for interesting props—I guess you could say it's an essential part of my photographic technique.

Today, capes are costumes; you usually see them in movies, on Broadway, or in old photos. I think my fascination with capes as clothing props began years ago when I did a photo of a model wearing a red cape at Westbury Gardens on Long Island. The photo of the model positioned between two trees and wearing a cape had such a great look and provoked such strong reactions that I used it as a pro motional card. It was a real attention getter. Some people saw a Little Red Riding Hood figure in a peaceful garden; to others, it was very eerie a mysterious figure in a cape in the forest. In any case, I knew I was onto something with capes. I went to Prague with only one model. I deliberately decided not to take two models, because I thought that might make Prague look like a commercial, tourist attraction city and I was going for a more mysterious look. I took with me three elegant, colorful capes that were specially made for the shoot. Two of them were reversible, so I had even more colors to work with. I rented a car and scouted around for locations for a few days. Then, I drove back to the places I'd noted and did the shooting. In one way, I was very fortunate: I got the kind of overcast, gray days that added so much atmosphere and drama to the photographs (I'd deliberately scheduled the trip for winter). On the other hand, I didn't get the snow that I'd hoped for. In a few cases, we got extraordinarily lucky and found old mansions and castles featuring painted trim that closely matched the colors of the capes. It looked like the capes belonged there, and the interplay of color, texture, and mood was perfect. I couldn't have planned it better.

I'm also a big fan of umbrellas. I have quite a number of them that I take to the beach. First of all, an umbrella makes great shade for a headshot—you can just put that over the subject's head and have diffused light. But it's also a neat prop. You can be shooting from a long distance and if someone has an umbrella waving in the air, that one detail can make a picture interesting, when it might have been boring otherwise. Even in the workshops I've conducted, we've always had a load of props available, so students know just by looking in the back of the car, "Oh, here's what I should be doing." Bring some things. Don't just stick a person out there and have them stand and do nothing. It helps

your models if they have a little something going on—unless of course they're just absolutely natural models who can create something outstanding just by body language or expression alone. All it takes is one little thing to transform a shot, and these are things you learn in time as you keep shooting and refining your skills.

In the Studio

Lighting in the Studio

I am extremely fortunate to be sponsored by Dyna-Lite, so my studio lighting needs are well covered. For most of my studio work, the front light—the light illuminating the models' and subjects' faces—is metered a stop lower than the backlight. This creates that nice, bright, high-key look that has come to define my preferred style of photography. When I shoot in the studio, the lighting is very consistent, because we don't want to have to stop dead in the middle of a shoot and readjust it. That can kill the wonderful energy that builds when all the elements of a shoot are working together. I will shoot a whole memory card, download it, look at the images, and then decide whether the light should change or not.

Props in the Studio

My studio prop closet holds a whole range of props; things like bathrobes and towels that would work for a spa stock image, a trampoline for active, jumping shots, various articles of clothing, and all sorts of toys for children. In the studio, the variables are more controllable, and this goes for props, too. I can run down the street and buy something if I need it, which is not something I can necessarily do on location.

If you have a specific vision in mind and you don't have the props for it, ask your models to bring in some of their own props. In the case of the amateur models, you can ask them what props they have a natural affinity for, or, in the case of kids, what toys they like to play with. When you get to know your subjects, you automatically learn what props work, but there's also no harm in asking them if you don't already know.

One of my favorite models is this little boy—he's a delightfully spontaneous kid. He arrived with his grandmother and promptly opened the trunk of the car, which was

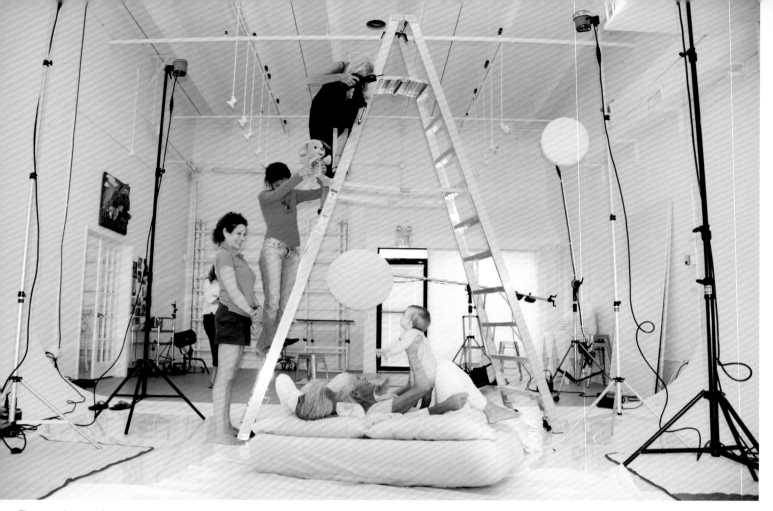

packed with an incredible collection of interesting objects. We also asked him to bring some things from home that he liked; he brought his bicycle and his little scooter. In fact, we ended up using all his own toys because he was so attached to them. He was also very particular with all of his playthings, and it was really entertaining.

Makeup and Hair Artists

While I will direct the look of the image and the model will carry that look, there is another important contributor on the set of almost all my photo shoots: The hair and makeup artist. I've worked with the same makeup and hair artist for many years in

New York and we are so used to working together that we didn't have to talk very much about the job—we just go about doing our part for creating fantastic images. She was very attuned to what is happening during the shoot; she saw what needed to be fixed and gets in there and quickly fixes it so that I could keep shooting. This flow is very important in a studio shoot; if we stopped everything to do makeup and hair fixes, we would lose momentum.

Since I have moved to Florida, I have been very fortunate to find two makeup and hair artists that are on my wavelength of creativity. They both offer a lot while working on a shoot, and have both become good friends. If they have an idea for a test or want to try a new makeup or hair look I do it, and vice versa when I want to try something. This flexible relationship makes us all more successful, and makes for a happier workplace.

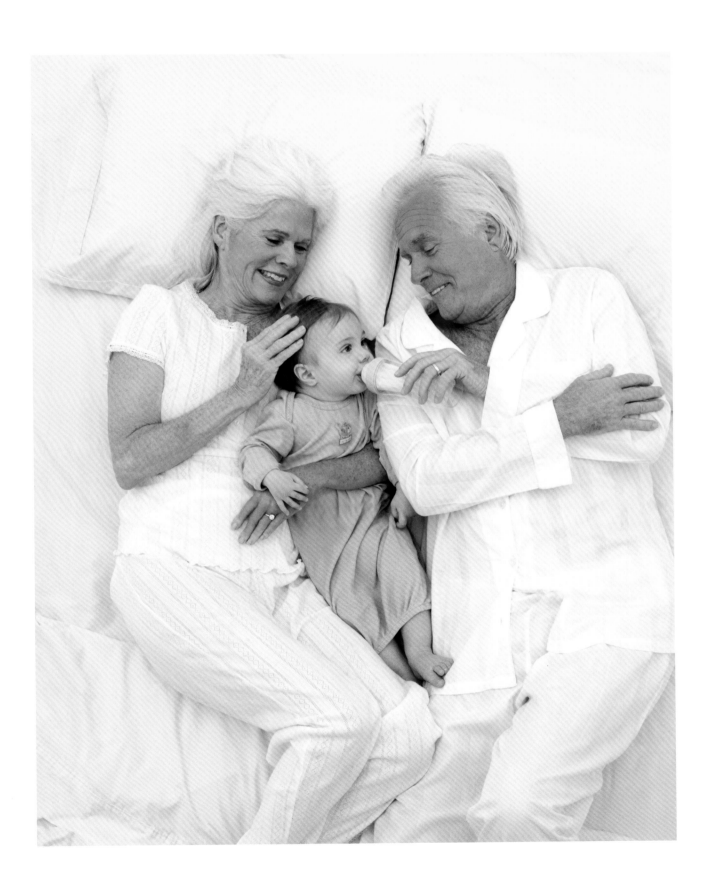

6 Stock and Commercial Photography

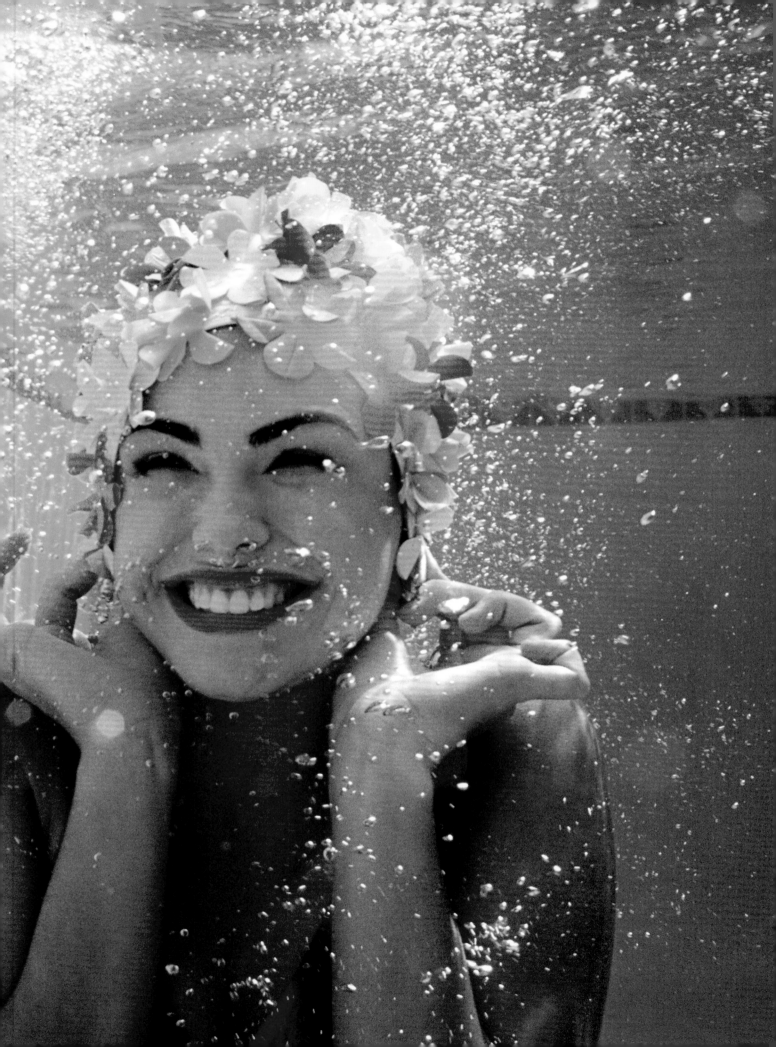

Stock Photography

The term "stock photography" refers to images represented by agencies (such as Getty) that act as a broker between the photographer and a commercial client. Stock agencies hold a large number of photos on file for companies to browse and purchase for various purposes—usually for ads, billboards, web use, brochures, posters, etc.—the agency is paid by the client for the images, and they pay the photographer a percentage. The photographer retains ownership of the images, and the images can be sold repeatedly to any number of clients. This arrangement works out well for both parties; commercial clients have access to an entire catalog of images applicable to any of their visual needs, and photographers receive exposure in an industry that they would most likely not be able to penetrate otherwise. There are various types of relationships in the stock image market between photographers and agencies and some benefit the photographer more than others, so you should do plenty of research and choose carefully should you decide that you want to work with one of these agencies.

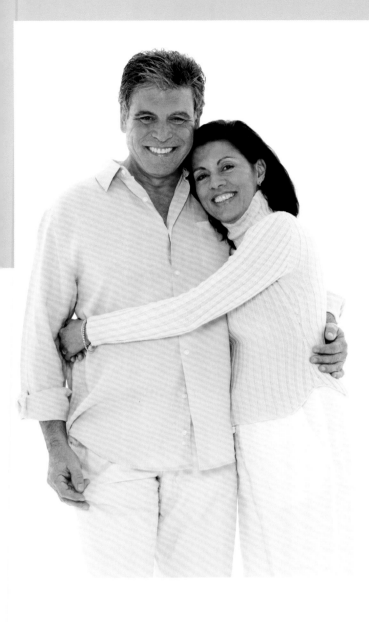
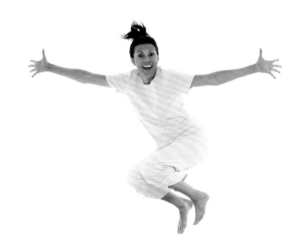
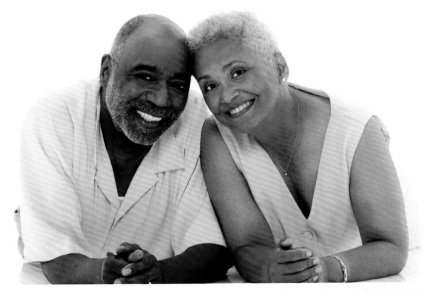

When considering stock agencies, you have to ask yourself, "Is it really a great place for my images or an effective way to break into professional photography?" I've always shot stock—it's my thing. But, why should you be interested in shooting images for stock agencies? Basically, it forces you to bring your photography to a higher level, and earn some money while doing it. Shooting stock will help you create better images because you won't be focused only on self-expression, you'll also be thinking about the needs of the end user. In a sense, shooting stock forces you to think like a pro.

For example, in the course of writing a chapter on stock for one of my previous books, I went through the whole process of creating a genre of images that would have a ready-made market among stock agencies. Since I'm a people photographer, I began by identifying a growing and important group of people whose images would be eagerly sought, in great demand, and easy to place: People in their 50s, 60s and 70s. Active middle-aged folks and seniors make up a huge percentage of the population now, and they're the focus of a lot of advertising campaigns and editorial coverage.

Bearing this concept in mind, we spent an entire day shooting this age group in the studio. We shot pictures of them jumping on a trampoline and hugging each other. Then, I moved the shoot outside and photographed them under an umbrella in the rain. I spent the day shooting older people doing "young" activities—I acted as if I were shooting a group of 20-year-olds. We made things look a little younger by using bright colors, make up, and the right environment. They loved being made up, too. A majority of my stock models are people of various ethnic backgrounds who are in their 50s and 60s and above because that's the trend now, and I go with it. You'll have a lot more success selling your images to stock agencies if you pay attention to trends in advertising and the media.

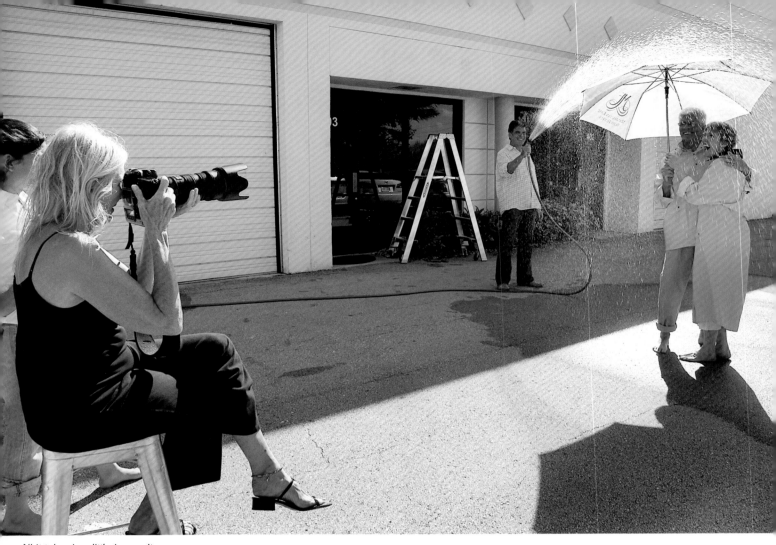

All it takes is a little ingenuity to set up a professional photo shoot, especially if you are working with limited resources. Take the time to look through magazine and online stock sources to get an idea of what the market is looking for, so that you can tailor your shoot towards a specific look, situation, or style.

Think Like a Pro

Contrary to popular belief, serious enthusiasts who are not full-time pros don't have to go to amateur sites to sell stock. Look at Getty—they went out and posted for amateurs. They did a whole big promotion in *Photo District News*. Some stock agencies do require that you submit a certain number of pictures, but others do not. This is becoming more and more common—leading stock agencies are opening up their doors and soliciting amateurs. There are two key points here. One is practical, that you may get your pictures sold for stock and published, and that's a good way to make a few extra dollars. The second is conceptual—the stock idea prevents you from falling into the typical amateur trap of,

you know, let's take a whole bunch of snapshots. It focuses your mind, giving you a clear sense of direction. What's more, it's a totally versatile way of thinking about your photography that you can apply to virtually any idea that comes into your head.

Why is this simple idea so effective? When you're thinking of a stock idea, with a particular end user in mind, you are automatically envisioning the finished product. You therefore do goal-oriented things like picking better colors, or asking your model to get their hair trimmed or colored, before even scheduling a shoot. You'll strive to make your pictures look a little bit better. Instead of going

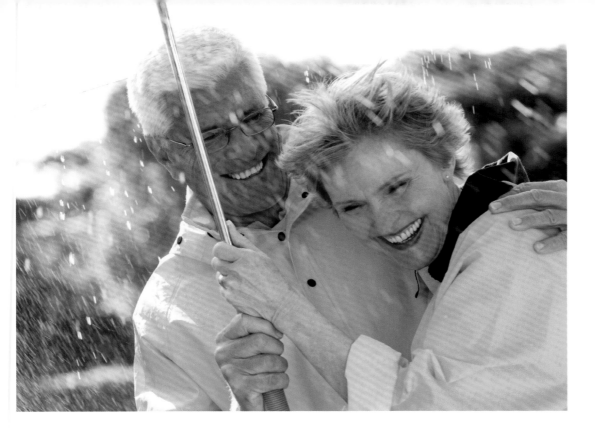

If you're thinking like a pro, you'll constantly be observing and learning, really paying attention to what's around you, and concentrating on improving every image for your next shoot. Whether you're determined to become a pro, just want to earn some money with your photography, or are a serious amateur trying to get better, it really doesn't matter. Developing a professional mindset is both fun and rewarding; and, digital can help you tremendously because you can see your results right away to see whether or not your techniques are working.

Market and Accessibility

In general, large stock agencies are changing their practices, making it much easier for amateurs or semi-pros to get their images out there. With so many established professionals shooting for them, why are they opening these doors? I'm not absolutely sure, but I believe they're looking for the cutting edge, or people with a fresh approach, or simply to make more money. One thing I am sure of is that these days, more stock images are being used than ever before. This is especially true for lifestyle images. They can never get enough of them. And they want them to be fresh and current, which means there's a constant demand.

out in the noonday sun, you might wait until later in the day when the light is warmer or until it's overcast and the light is softer. Instead of shooting in a plain old backyard that doesn't look particularly nice, you may go out to a park where you know there's a pretty setting. Maybe you'll go to the beach if you have one nearby because it provides a more natural and expansive background than the local swimming pool with its fences, concrete, and enclosures. Perhaps you will look at photographs and ads in the top magazines to see what's selling, and think to yourself, "Gee, I could do something like that." And, when you do all of these things, you'll suddenly discover that your images are beginning to look more exciting, compelling, and professional.

Another interesting aspect of this is the globalization of the stock image market. Right now, through Getty, I am selling in more foreign markets than American ones, and it's fair to say that most of us pros who sell stock are in the same place—we sell more outside of the U.S. than inside. I don't know why that is, but all of these factors increase your odds of having your images placed with an agency.

Salability

You can think about stock potential when you photograph your relatives, too, creating salable stock images while making pictures that they will treasure as personal mementos. For instance, when you see your father hop on his bike every morning, it can make a really neat shot to frame and present to him on Father's Day. However, it can also be a great stock shot in the ever-popular "active seniors" category and end up on the pages of a magazine. I think many pros and semi-pros are shooting pictures of their own relatives, the grandkids with the grandma and grand-dad, that kind of thing. You see more of that now because family members are accessible, and you don't have to pay any upfront mod-eling fees. In any case, taking pictures like that is just a neat thing to do for yourself and for your family.

A good example of that is the shoot I did with my granddaughter and the pumpkins. Of course, I have personal motives to photograph my grandchildren, but business was in the back of my mind. I know that stock agencies are always on the lookout for well-executed, holi-day-oriented photographs and I'm confident that one or another of those images is going to get purchased and used by next Halloween.

Photography is a great and fulfilling hobby, and whether you're a serious amateur or aspire to be a pro, you can have fun and hone your skills at the same time. One thing that will help you do this is to always ask yourself how you can make each picture bet-ter before pressing the shutter release. It may be something as simple as not letting dad wear that old black shirt; have him put on a nice light blue one, something to make it nicer. Or, it could mean getting a little closer and filling more of the frame with your sub-ject. It's a combination of forethought and spontaneity that will help you to create memorable and compelling photographs.

Attention to Detail

Details are also important, since they spell the difference between shots that are show-stoppers and ones that are run-of-the-mill or look amateurish. When it comes to portraits or lifestyle pictures of people, it's usually the lapses in styling and lighting that prevent an otherwise pleasing image from being a winner. Many photographers, even pros, don't bother to go out at the right time of day, comb somebody's hair, or ask the subject to change the stained shirt and put on a fresh one. Little things like that make such a big difference that it's no wonder one photographer's pictures can look so much better than another's. You've got to train yourself to see those little subtleties, because each one can make an enormous difference. They make one shot a winner and another a loser. One

picture makes someone say "Wow, Dad looks really great!" and another falls flat. Well it's not Dad; Dad looks the same. But, you have control over everything around him, and those are the things that can make the difference.

Of course, having flash skills and using different lighting setups expertly also helps because there's a lot of production value in any shot you take, especially if it's made in a controlled or studio situation. That skill set includes using other accessories, shooting through rough diffusion material, bouncing continuous light (floods) or flash off of walls and ceilings, or using auto-balanced fill flash outdoors, among other things.

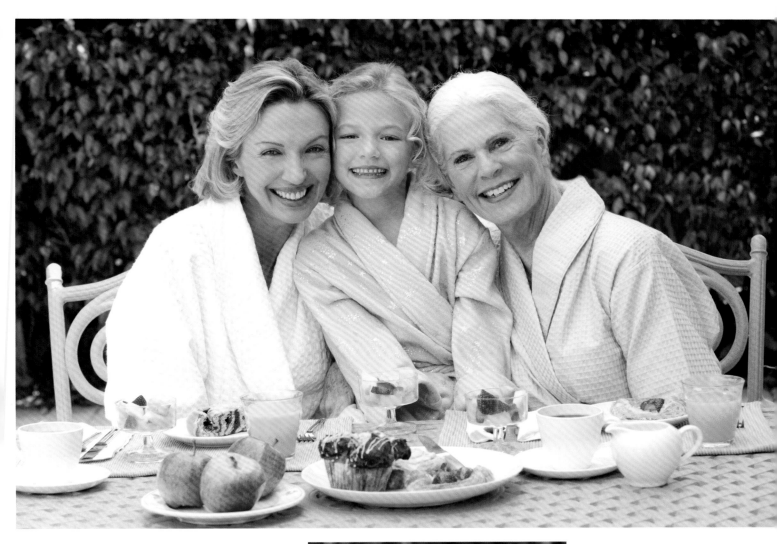

Basically, my approach is centered on people. If I want to create images that look different, I'll use different people. Instead of using the stereotypical family—father, mother, and the little kids—I now go to the grandparents or the great-grandparents. I am successful because I change my subjects to meet the market demand but my approach is basically the same. They still need what I do more than any other genre. Many other photographers won't shoot portraits. It costs money to produce those pictures because it involves a lot of setup, but I've made the commitment to hang in there and do the work, and that's why I continue to be successful.

Shooting for Stock: The Digital Advantage

Shooting stock is a creative process, the object of which is making images that stand out and capture the viewer's (and potential buyer's) imagination and engage their emotions. That's why it's the time to experiment; it's the time to use those things you've learned, and to make them pay off. The beauty of digital imaging is that you can see it right in front of you. And with digital, you can combine images and create amazing collages and composites using an image you've already shot and saved. For instance, say you go to the beach in search of a great sunset, and it's terrible, there's no sunset. Well, if you have a suitable sunset sky image in your files you can usually combine it with your beach foreground to create a convincing image of the scene that got away. These are relatively simple things that anyone can do with a minimum of hands-on experience. In the digital era, when you look at the image on the screen and think that it works but it could be so much better if you could just add that one thing, that thing that transforms the image into a winner is probably just a couple of mouse clicks away! Yes, this is a brave new digital world, and it's a great time for photo enthusiast and pros, especially those who specialize in pictures of people.

There are some professionals out there who feel threatened by all this newfound power in the hands of serious amateurs who are potential competitors, but personally I never have. I've always shot the same kind of photos from film days all the way up to the present. The only thing I've done differently is to move into the computer age and take full advantage of the technology.

Digital is different, all right, but it's very fulfilling. These days, like most pros, I've become the processor, the lab, and the art director. I edit much tighter, and every week it's different. Pretty soon we'll be sending it in to the client's File Transfer Protocol (FTP) site with everything done. It seems to change every month—and we do more than ever. Everything now is on FTP, an amazing method of sending big files from one computer to another, regardless of location, over a network that works more or less like the Internet. There are no match prints and there's no paperwork. Our client base is keeping up with the latest technology, so we have to as well. The closer you can come to achieving this goal yourself, the more successful you're likely to be. Even though there are no match prints, this type of processing is still more expensive than dealing with film because of all the time and money spent on digital color management.

Stock vs. Commercial

Commercial photography (or assignment photography) is different from stock photography in that the client has specifically requested the photos you create for an assignment. The client pays you and the images are his to use under whatever terms you work out with him. I never put any assignment in stock.

In my particular case, when it comes to shooting, there is actually very little difference between what I do on assignment and what I do for stock. For example, I recently shot an older woman with her 40-something daughter and her granddaughter—three generations in the same images. We took some pictures in the garden, by the pool, and then something a little different—the whole trio with surfboards and wet suits. Now, I happened to shoot that series for stock, but it could just as well have been for a specific assignment. The confines are a little bit stricter for commercial jobs because you have to get what the client wants, but there is almost always plenty of room for creativity.

The huge difference in shooting stock rather than for assignments is that you have a lot more flexibility—you don't have to deliver specific images demanded by the client. Take the beach sequence, for example (part of the three-generations shot I just mentioned). As it turned out, we had the grandmother, the 40 year old, the little girl, and another little boy available. Well, the little girl that came to the beach was not on her best behavior, and that could've put the kibosh on the whole thing if I'd been shooting for a specific assignment. Since I was doing stock, I knew I could quickly press the little boy into service as the "grandson" until that little girl decided to smile, which she finally did in a few of the last photos.

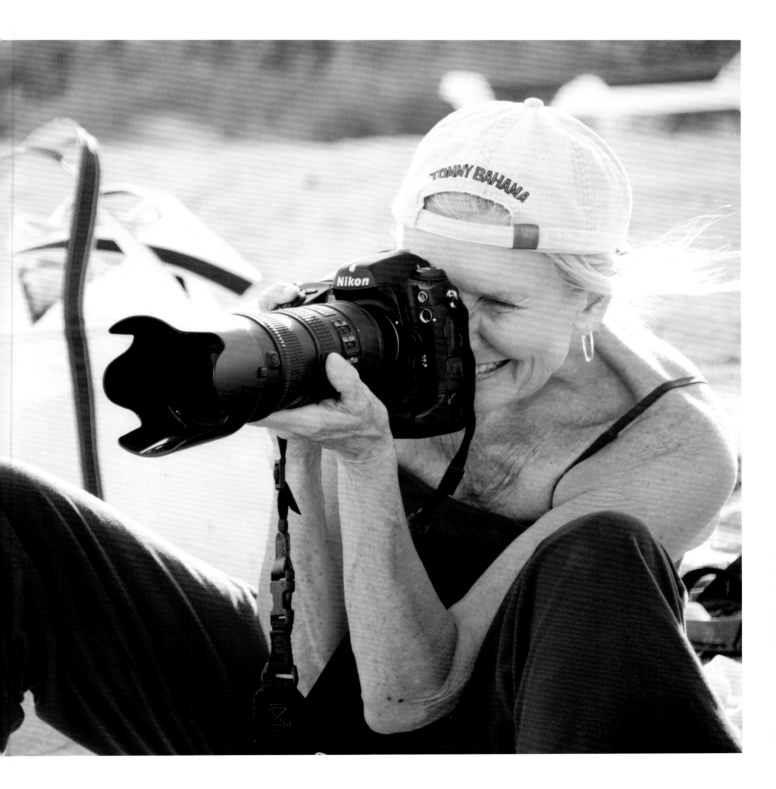

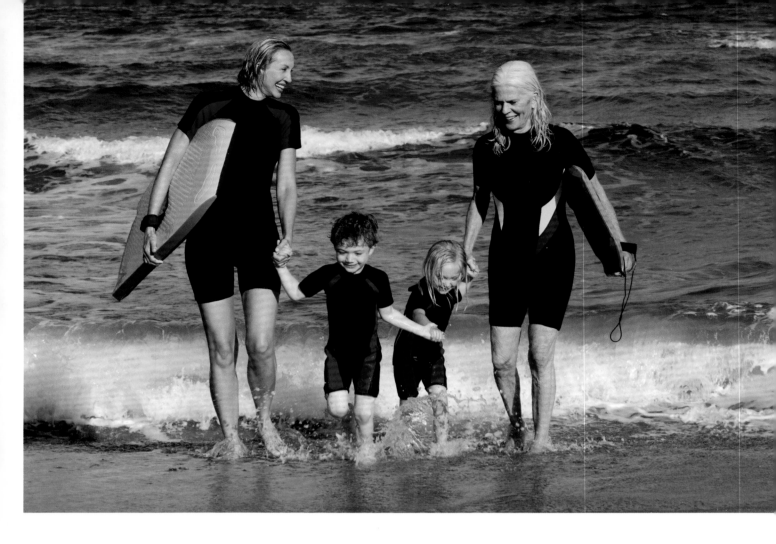

Had I been shooting a job, this would have been a major inconvenience. We probably would have had to force that child to try to give us a pleasant expression, which seldom gives you exactly what you want. In this case, I just changed the concept of it in my mind; it was a mother, grandmother, and grandson. On a job, that would not have been an option. Yes, I would've had backup kids in that situation, too, but if there had been a client expecting some images of just the grandmother, daughter, and granddaughter, we might have had to reschedule the shoot. Since it was just for stock, though, we were able to improvise as much as we needed to and be done with it. So, the difference is that I'm in charge. With stock I kind of go with the flow, let it go how it goes, and capture moments rather than do a layout. When you're shooting stock, you can take this more relaxed approach and just let things happen.

Letting things happen doesn't necessarily mean your approach is haphazard or totally unstructured, though. Even when I'm going for whatever happens, it often takes a few memory cards to get it right, because I'm still going for something definite, something that clearly makes it better, an image that stands out from the rest. In short, even when you're shooting in the moment, you have to have a clear idea of what works and what you're trying to achieve.

Of course when I'm shooting an assignment, the concepts come from the client. And not only the concepts, but also the location, the model, even the type of lighting. If it's a location shoot, I'll scout the location days ahead so I'll know what I'm dealing with, but the choice of that location and the look of the photograph come from the person who's paying the bills. If my idea of the shot doesn't coincide with theirs, even if I'm sure I could do it better, I have to do it their way.

I once did a great picture for Maybelline cosmetics—a girl on a swing, shot in the studio with a beautiful painted background that we had specially made. The picture was beautiful. At one point the client had a 16 x 20-inch print (40.6 x 50.8 cm) on a desk in one of the corporate offices. The image was all set to go into print, and a secretary walked by and said, "My gosh, it looks just like a painting. It doesn't look real." Right then, everything changed. We had to go out on location and shoot the setup under a real tree. They paid for the whole thing over again. Fine, that's their privilege, but in my opinion, the picture we took outside under the tree wasn't even close to the beauty of the shot we got in the studio. I didn't even put the location shot in my portfolio.

If you have a good relationship with the client or if you instinctively feel that the client trusts you, what you try to do is get a few shots the way you see it. You do exactly what the art director wants and then you say, "Hey, let me try something—I have an idea." If there's time to do it, and if you're working with a good art director, or one who knows your track record, they will probably give you a shot at it.

The best situation is when the client hires me for my ideas. Perhaps it's someone I've worked with for a long time or someone who specifically wants what I do best. I shot for Maidenform for five years and worked with an art director who'd essentially pick the lingerie we had to shoot and then let me work with it and the models. That's not the way it usually works when you shoot for advertising, and in a way, having the shot laid out for you is a good thing. It's good to have the experience of working according to someone else's plan. It's good discipline—it teaches you what you need to get the photograph. And it can give you some insight as to what's going on in the business.

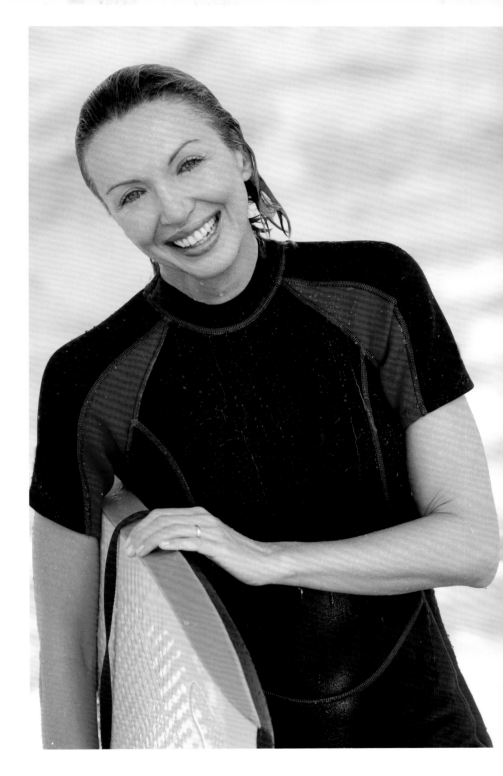

The discipline and experience of shooting for a client pays off in confidence when I'm shooting for myself, for stock, or for a model's portfolio. I have to go into the shoot with a pretty clear idea of what I want. And I have to be confident that I'll get it. Let me tell you—without confidence, no one goes to Prague with a model and a trunk full of multicolored capes!

Post-Processing

The next huge step, of course, is downloading your images to your computer and getting them into Photoshop. This is by far the quickest and most effective way to take your image to the next level. Say you shoot people in front of a hedge, and the expressions are fantastic but there are a few leaves in the way that look awful. You can now simply eliminate them in an instant by using a few very basic and easy-to-learn computer skills, whereas before, you were pretty much stuck with what you had. If something ruins your image now, it can easily be fixed. Now, I'm not telling you to fix everything in Photoshop because that is way too time-consuming; it's much faster if you get a good shot initially. But, I am telling you that if you can operate a cell phone or an iPod, you can easily learn most of the basic Photoshop skills you'll need. And, chances are, your local college offers inexpensive courses in basic Photoshop to get you started.

While I consider Photoshop to be essential in my work, I come out of the highly disciplined medium of film and I certainly haven't become one of those we'll-fix-it-in-Photoshop people. I strive to make the picture as perfect as possible at the moment of exposure and to get it right the first time. True, I'm a little less fanatical than I used to be. I used to rake the beach before a shoot, but I now I can clean up the worst parts and fix minor defects in post-production. However, even as powerful a tool as Photoshop can't make bad pictures into good ones. You still have to have a shooting plan: a precise idea of what you're going to do with your subjects, and the look you want to achieve. You can't plan your images in Photoshop, you can only correct, fix, and enhance them. You have to start with something—namely, a clear idea of what the end product will look like. Unfortunately, many photographers are no longer taking this approach—they aren't starting with something. They're skipping the vital step of starting with a well-defined concept. "It's so easy to go in and fix afterwards," they think. But you can't work backwards. You can't fix something that isn't good to begin with.

It's also important to remember that time is money. The more time you spend in front of your computer editing photos, the less lucrative it will seem when you sell your images. If you spend half a day shooting and an entire day fixing problems that could have been avoided on the front end, you've just wasted that second day. You could have been out shooting more potential stock photos instead. And, your hourly rate just went down considerably. Less time spent in post-production means more income going directly into your pocket.

In short, what you need to work on in the digital world is a sense of balance that combines the elements of forethought, execution, and post-production in a harmonious way. There are a lot of individual elements that go into striking that perfect balance. Lighting is crucial and you can play with it as a part of the creative process, but you can't create something out of nothing. You've got to have idea or conception to start with—a visual image in your head. You may seldom achieve it precisely, but it's important to at least start with a clear goal. Having a well-defined conception of what you're aiming for is especially important when you're shooting stock images. Stock agencies really look for photographers who can present a cohesive body of well-executed work with a certain style and subject matter that will sell. They'll sign you up if you can present something like that, whether you're an amateur, a seasoned pro, or anything in between.

Post Production

7

Adobe Camera RAW

I do all of my own editing, cropping, and basic post-production enhancement in Camera RAW, a part of Adobe's Creative Suite software. When you shoot in RAW, you can do anything you want to without affecting the quality of the original digital image. While I don't do much heavy-duty enhancement (switching backgrounds, altering details, or fixing blemishes), I do get each selected image to a point where I know exactly what the final result will look like. For example, I may tweak the color balance to get the effect I want or to express what I envisioned when I was shooting the photo.

Before Camera RAW, there was no really effective way to do this preliminary step of post-production, of "pre-processing" the RAW image files before handing them off to a bona fide Photoshop expert—it was Photoshop or bust! The important concept to get your head around is that a RAW image file is not really an image yet—it is kind of analogous to a negative. It's a basic record of the RAW data—pixels, not a picture. We never send out our RAW files just as we didn't send out our negatives when we were shooting film in the old days. We usually provide clients or agencies with large, hi-resolution TIFFs or, more recently, hi-res 4MB JPEGs. Once I do my initial post-processing in Camera RAW, I turn the images over to my amazingly capable Photoshop tech and we determine what's needed to bring them to a state of artistic and commercial perfection.

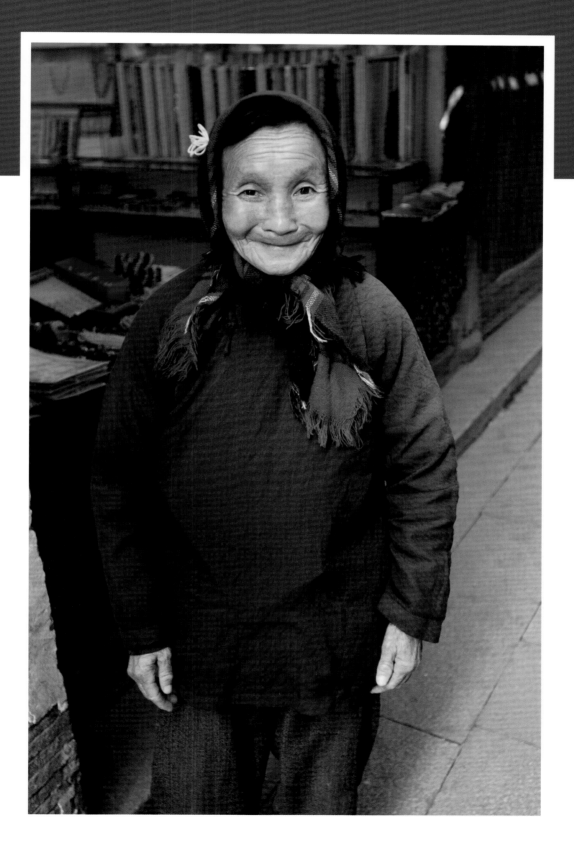

Photoshop

To give you the clearest possible picture of how we use the latest Photoshop software in our post-production process, the best way is to let my indispensable Photoshop genius, Safaa Idyouss, speak for herself on how we work together.

Safaa: Most of my work consists of digitally retouching pictures in Photoshop. After I upload the RAW image files, Nancy and I edit the pictures and pick the final shots. We do as much work as possible in Camera RAW before processing the file in 16-bit format, and here's a basic description of the process.

With pictures of people, we adjust the exposure and the color temperature sliders according to the photo. Sometimes we use the fill light slider if the image is backlit. For scenic images, we tend to use the saturation or vibrance sliders to give the image a little extra punch of color. The clarity slider can also help if you're trying to sharpen the image just slightly without giving it a "manipulated" look. Camera RAW is a very important tool for us and we take full advantage of it since it doesn't have any adverse effects on the image quality. As long as you have your original RAW file, you can always go back. On the right is a good example where we changed the color to give the picture a different feeling. We ended up liking it both ways so we sent both versions to our agency.

There is so much you can do to an image once you take it to Photoshop. You can go from a minimal color adjustment to major plastic surgery. Different tools can accomplish different things, and you have to learn how to juggle and switch back and forth between your tools in order to get the results that you want—you can't really give precise instructions for this; you've got to learn by doing it.

Digital photography is much more unforgiving than film because it is so sharp and all of the details really come to life. So, we almost always have to do retouching on faces. On images of models, we begin the retouching process by eliminating wrinkles and blemishes, and smoothing the skin. My favorite tool to use is the healing brush tool because it smoothes any obvious facial lines as well as blends the pixels to make it difficult to notice obvious retouching. Sometimes I use the paintbrush with a 10% or lower opacity. This gives the skin a nice finish. Retouching can be tricky, and sometimes you can overdo it without realizing. That's why you must work with layers so you'll be able to go back and correct your mistakes without affecting your original image.

Exaggerated retouching ruins a photo. Too much retouching, especially under the eyes, should be avoided. By all means, soften facial lines and remove some of them entirely, but don't overdo it and make your model look fake. That's when I use the clone tool at about 12% opacity in either lighten or normal mode. By cloning from a clean area without lines you can help lighten up any circles underneath the eyes. The clone stamp tool simply copies information from one area to the other. However, you need to keep an eye on your brush diameter, hardness, and opacity settings in order for it to work properly. If the brush is too soft, it might make the retouched area look blurry and blotchy.

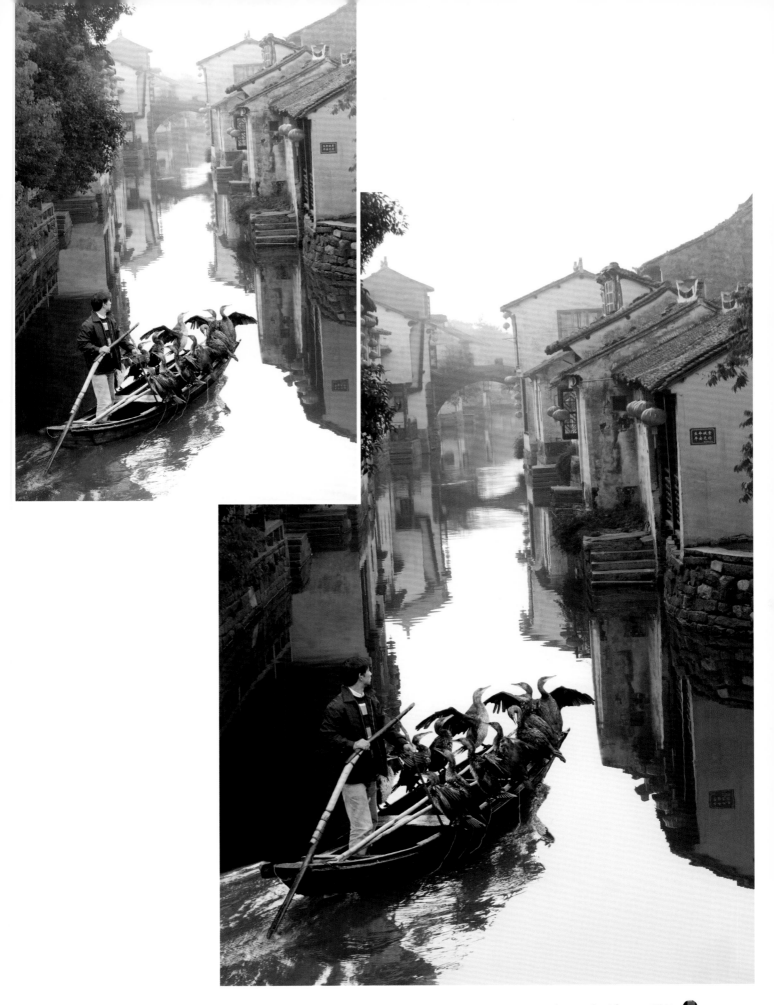

The image to the left is a perfect example of retouching on an aging woman's face. As you can see, we minimized the lines in the face and neck, but did not get rid of them totally. We also eliminated some spots, and cleaned up some of the mascara. In addition, the hair was loose on the sides, so we cleaned it up using the clone tool at 100% opacity and carefully cloned from the white areas behind her. Finally, the model forgot to take off one of her earrings, so I had to clone that, as well. The photo is more salable now.

On the next model (middle and lower left), I did what I would call basic retouching. The original image is on top. The model had amazing skin to begin with. However, we still had to retouch under the eyes, clean up some of the hairs on her arm, and smooth the skin in some other areas. Also, you may have noticed on the first image (top), the light hit the side of the left eyebrow. I had to clone some of the skin to cover that area.

Here is the same model running on the beach—the "before" image is at the top right. I had to do a lot of work on this one. We straightened the horizon in Camera RAW using the straightening tool. It does a great job of straightening out your shots, but if the horizon is too crooked, your picture will get cropped a lot. There is another way to straighten the horizon by selecting the horizon line on a separate layer and moving it around (command + "T" is the keyboard shortcut) until you make it straighter; then you just clone around the edges to make it more believable. Since the model was running, it was hard to get the picture sharp enough for our agency. In fact, I had to get a sharp face from another image and put it on her body! I also cleaned up the tracks on the sand, and removed part of the building in the background. Finally, we changed the overall color to give it a mood—pink for a warmer, more late-in-the-day feeling.

Sometimes when working with a family you might have one individual who is simply having a bad day, and that manages to ruin a lot of photos. By using part of an image of that same person from another photo, like a good face, and placing it on their body in the other photo, you can often rescue the shot and produce an outstanding image. All you have to do is select the face that you like from one image and put it on its own layer (command + "J" is the keyboard shortcut). Then, you move that layer that you just created to the new image (the one with the bad face). Keep moving it around until you get it in the right spot. You can then make a mask around that layer and paint the edges until you seamlessly blend the face with the body. The trick is to use photos with very similar lighting and poses as guides. In effect, you are limited to the couple of shots taken just before or after the shot you're working with. Also, by combining two images like a model from one photo and a background from another, it's possible to make an ordinary image more effective and salable. A good example: Replacing a boring background with a sunset in a picture of a model shot under similar lighting conditions.

We did a stock day with babies on a white background. As you probably know, babies are among the most unpredictable subjects to photograph. Everything depends on their mood so you must always have other babies to replace the ones who are crying on the set. We also had to use all kinds of entertaining tricks to distract or entertain them, like blowing bubbles and shaking keys, sometimes even singing for them.

In this picture, four babies were looking up at the bubble, but the fifth one, the second from the left, refused to cooperate. All we had to do was take a face where she was looking up from another shot, and replace it. We also removed some bubbles from the floor and from in front of the baby on the far left.

In the example above, Nancy was trying to get three babies from different ethnicities into one shot. Unfortunately the Asian baby was not cooperating at the time. So we shot him by himself later, and added him to the group in the final image. We also needed the baby on the left to be smiling, so we replaced her also, using an image of her from another picture where she was smiling.

With babies, you can't shoot for too long because they tire easily, so you try to get your main shots in as quickly as possible. That way, even if your plan doesn't work out, you can cut and paste them using the computer as long as you have the right expressions.

Also, by combining two images like a model from one photo and a background from another, you can make an ordinary image into something special. For example, you can add a sunset to create a more dynamic picture.

In the example below, we blended the sky with another sky that Nancy had shot previously. The mood of the image is totally transformed. We also warmed up the skin tones on the father and the baby to match the lighting.

By changing the opacity on the top layer, which is the new warm sky, we were able to control the color, and make it more believable.

In this photo, I used the masking technique. You create a mask attached to your layer, and paint with a soft brush to reveal only what you want the viewer to see. Take a look at my layers palette. The bottom layer is the "before" image, and the top one is the sky that I want to add. Create a layer mask by clicking on the box at the bottom of the layer palette marked in red, and then start painting with a black brush on a white background to hide or reveal more of the sky. Go back and forth between a black and a white brush to refine the edges of your mask until you get the precise result that you want.

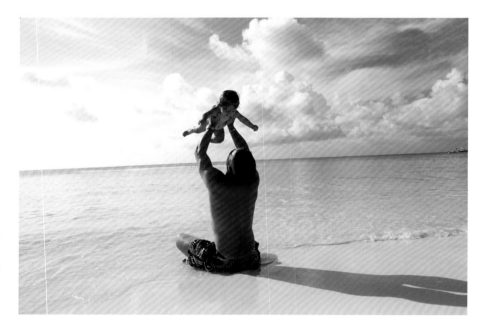

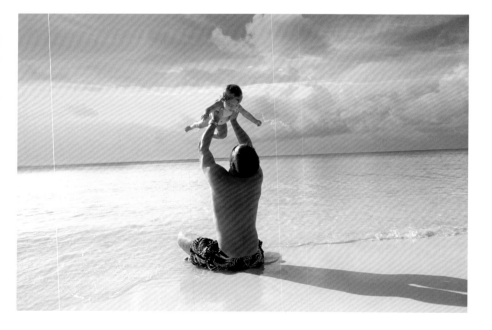

In the second example to the right, we shot an image in the studio because the weather outside was atrocious. We knew we could add a sky in later in Photoshop to give it an outdoor feeling.

We purposely backlit the couple's headshot to match the light in the sky we had shot another day. And, using the same masking technique illustrated earlier, we easily replaced the gray background with a dappled blue sky.

We work mainly with Getty Images, and they are very demanding regarding the photos they accept. They punctually review every pixel from each image and if your retouching is obvious or sloppy, they will reject the image. That's why we make sure to remove any trace of banding, noise, color fringing, etc., before submitting them to Getty.

Yes, Photoshop is an excellent and indispensable tool for making great images even better, but it is not a substitute for shortcutting the proper digital capture. Unfortunately a lot of people think that they can just "fix it later in Photoshop." That is the wrong approach. You should do as much as possible with the camera at the moment of exposure and not rely on Photoshop to save you afterwards. Nancy Brown understands this very well because she started her professional career in the film era, and that's one reason it's such a pleasure working with her.

In this last example, I created a simple Christmas card that did not require any retouching. We shot the ornament separately in the studio under the same lighting, and resized it to fit in our picture. We were able to turn a simple picture to a nice Christmas card for Nancy. The two little girls happen to be her granddaughters.

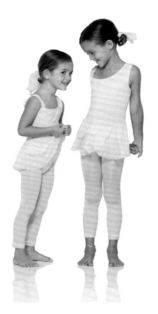

The Biz

8

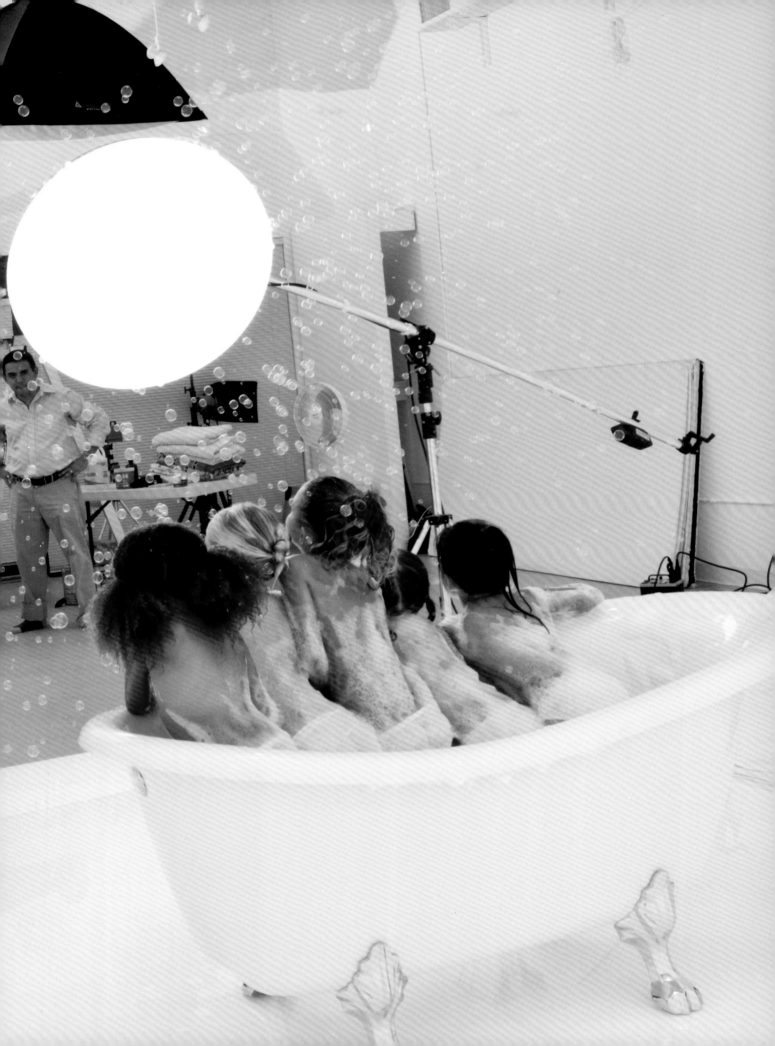

Things change in this business. Tastes change, assignments change, the art directors and photo buyers change. And, often, photographers have to change their approach. But, don't change your entire style. Talented photographers who have good technique, ideas, and a style are always going to survive. But, these days, it takes a lot more perseverance to become and stay successful. It's easier to get good photographs today—the equipment is a lot better and a lot more automatic. But, what people are buying is style and vision. Art directors and picture buyers are always looking for something new or something reborn. A new approach, a new slant, a new face—anything they haven't seen before. Most of all, you have to keep shooting, keep creating new work. You can't present the same portfolio, the same mailer, and photographs of the same models year after year.

Over the years, I've had to change my subjects and even my approach to keep up with what buyers are buying. I don't do the real dreamy, grainy, girls in white dresses with umbrellas anymore. Now what I do is more realistic, more catch-the-moment, catch the laugh, the smile, the jump. We are not into the dreamy world anymore; that look is over—for now.

Promotion

Sometimes it just comes down to luck and timing—just having your work seen by the art director who's looking for the kind of work you do. No matter how hard it is, though, I'll guarantee one thing: Art directors will remember you if you have good work. And, if you send promotional updates on your work, they'll think of you when the right job comes up. Otherwise, how is anyone going to know what you're doing?

When I was in New York working all the time, there were a handful of us that had basically similar photographic approaches. When I'd compete for a specific job, I would be up against those same people every time. But, maybe the art directors saw a little something extra in one person's book that stood out. And, since this choice had economic consequences, if they chose me, I tried to figure out what made them do it.

Art directors are also looking for consistency and reliability. They have to be able to count on the photographers they hire to deliver on time and on budget.

Nowadays, editing software makes it easier for buyers to make new pictures from older ones. But, the good photographer with a specialty, a vision, and a style is still going to be in demand. A lot of people can do the manipulating, but when you come down to it, not as many people can make the great images from the start.

Starting out in the business today is, I think, a lot harder. When I began, I could call an art director at an agency and get an appointment to show my book. That's over. There are too many photographers, and art directors don't have the time or patience. You're lucky if you can even get them to look at your work.

You might think that this is a kind of pandering—find out exactly what the client is looking for and give it to him. Maybe it is, but the reality of photography as a business is this: Authenticity is certainly important, but so is understanding a client's taste and style. If my pictures had a little bit softer feel or were a little less hard-edged than the next person's, and that was the way they were going, then it would be my job. If it wasn't, one of the others would get it. So, in theory, the more flexible you can be (without overextending yourself, of course), the more jobs you can get. One thing is certain: Once you find your style, you will still need to be able to work flexibly within it (and occasionally outside of it) if you want to sell your photos.

I'd suggest having a portfolio for every spe-cialty—like lifestyle, beauty, and fashion. I have a kids page, a travel page, and several other specific pages on my website. And, my portfolio changes all the time according to market trends. Keep it fresh!

In addition to a web site and portfolios, I also use the professional directories. One thing you have to realize about directories, though, is that you can't expect immediate, unbelievable results. As with most means of advertising, the response to directory listings can be described as more of a trickle than a rush.

Of course, these days, the Internet plays a part in everything. If you're a photographer, you have to have a Web site. I've had my site for a long time now, and it works. I get email and telephone inquiries. But the most impor-

tant thing about it is I'm able to say, "You can see more of my work on my website." I know it's gotten me workshop participation, too. People see the work and want to learn more about how I create it.

It has been said that most success in life comes from just showing up. Be there. I have, for over 30 years: In showcase books, in promotions, and now on the Web.

Of course, I had a bit of an advantage when I started. I'd been a model and knew a lot of people. I'd say, "Hi, this is Nancy Brown, I worked with you on the so and so account, and now I'm a photographer." They were probably thinking, "Oh, no," but at the very least they agreed to see me. I got in the door. These days you're lucky to get your book in the door, but anything that does open the door can be beneficial.

Setting Prices

No matter what you're shooting or where you're promoting it, you have to know what it's worth. It's one of the biggest concerns of photographers: What do I charge?

I base just about everything on usage. Is the photo for an ad in a national magazine or for a local public relations effort? Is it for a point of purchase display in a chain store or for a statewide bill board? Your photo is worth a lot more if it's on a bill-board than if it's on the inside back cover of a trade magazine.

Day rates for photographers can vary accord-ing to how big their reputations are or in what city they work, but the first thing to consider is how the photo is going to be used. Then, I'd adjust the fee based on the degree of difficulty of the shot. The photo may be for a trade ad, but if the shoot is going to be difficult, I might charge as much as I would for a consumer ad. Always think about use, time, creativity, and difficulty.

Where do photographers get the use figures? I use a software program called FotoQuote, by Cradoc, as a guide. There are also lots of guidebooks available and the professional organizations, like Professional Photographers of America (PPA) and American Society of Media Photographers (ASMP), help their members price their work.

When you work with a stock agency, it's eas-ier because they'll set the prices for you. You get your percentage and that's it.

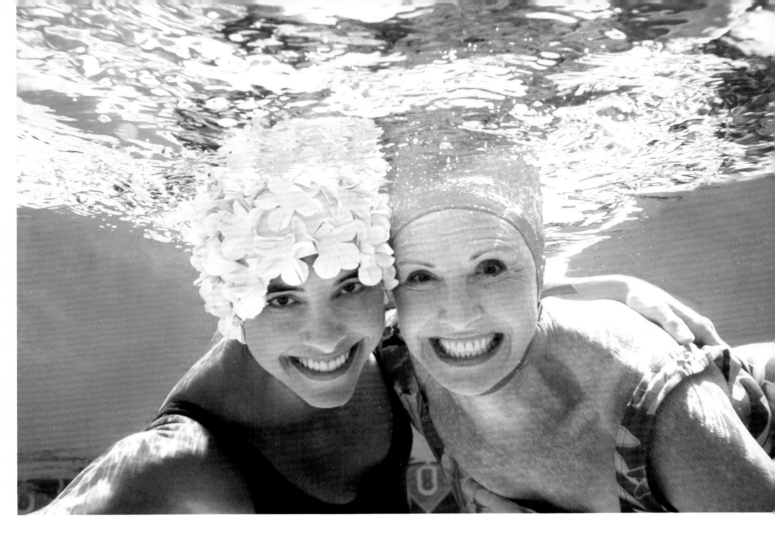

Expenses/Overhead

Just like in any business, you have to spend money to make money, but if you're smart about it, you can really maximize your profits.

It is a huge monthly expenditure to maintain a studio, but there are ways around that. When you're getting started, if you absolutely must work in a studio, it might make more sense for you to rent space as needed. You may also consider putting together a small studio in an extra room in your home. This can also be a great way to make some money doing family portraits!

Location photography can be less expensive than studio photography because you don't have the expenses of the physical studio to carry. There are, however, plenty of expenses to consider for location photography too, such as travel, food, accommodations, and paying models. One of the things I can do to minimize expenses for on-location shoots is to work out a deal with my models in which I pay them for the trip and give them a lot of photographs for their portfolios. Of course, for a location shoot, I pay them less than I would for days in the studio. For example, in the studio I'll pay a certain amount per day, but if I take a model on location, I would work out a weekly rate plus expenses.

Models usually love to go on location, and I've never had trouble finding models at rates that make sense for me. I once did a location shoot in France and brought a dozen models at very reasonable rates. That trip was, as you might imagine, a big money deal. I shot stills and film, all for stock, and it was a huge investment that took over a year to pay off.

The way to make location photography really pay off is to get a lot of mileage from the images. If I just did one thing with the pictures, I might not get my investment money back. So, I try to cover a lot of bases—it's not just beauty—it's health, faces, stock situations, etc. True, I might sell one shot from a trip for a whole lot of money, but I don't count on that. I count on the long term, little by little sales. That's the realistic approach.

Be Professional!

Always try to maintain a professional atmosphere, whether you're shooting in a studio or on location. This will earn you trust among the people you work with, as well as add value to the services that you provide.

Be organized. As a model, I hated it when the photographer was disorganized. I'd walk into studios that were in chaos—the background wasn't up, the lights weren't in position, people were running around, and the client was standing there waiting. It wasn't a good atmosphere.

One of the photographers I used to work for had a favorite line to cover any number of problems: "Don't worry, we'll retouch it." He moved fast—he was, in fact, well known for getting the job done quickly—but he had no finesse.

Don't over-direct. Other photographers tended to give too many instructions as if they had to demonstrate that they had a lot of ideas and were in total control. Over-directing can really disrupt what might otherwise be a very smooth-moving session. I direct my models, but I know enough not to try to over-control the situation.

The next is perhaps a subtle point. When I was a model, I could always sense when a photographer was enjoying his job, when it was not considered a chore. And, I liked working with those photographers. I think models give their best when there's a sense of enjoyment, even of fun, in the room. You can't always get it, but I remember how important it was.

The other things are pure common sense: A clean, warm (or cool), comfortable studio. And, one that's bright—as a model I always hated it when a studio was a dark hole. I'd be there all day and couldn't see the sun. I think that a light, bright, sunny space gives people a positive attitude.

Testing Ideas: Expand Your Creative Horizons

Almost all of what I do is for a specific purpose—either to fulfill stock assignments, for a client's advertising, for a model's portfolio, or to provide images for this book! There are times when I like to shoot pretty much for the sake of trying something new or what I call testing out an idea. I think it's a good idea for all photographers to find the time to do this—just to experiment and express themselves. I had a day planned with a model, who, besides being extraordinarily beautiful,

is a really outstanding professional. She offers a lot when being photographed and that is such a plus for me. We were doing a daylong shoot for my stock agency of the typical sellable situations: business, healthy lifestyles, beauty at the beach, and commercial headshots. I decided that after my disciplined situations were done I would do some testing on beauty ideas for myself that I haven't done in a while. Also, my makeup and hair person, who was along with us that day, wanted to do some testing for her own

portfolio. She was more than happy to change the model's makeup from a commercial look to a clean, beauty-oriented one.

I had wanted to do some reflection images to add to my beauty portfolio for quite a while and since we were getting such good pictures and having such fun, now seemed like a good time to go for it. I took a mirror off the wall in the studio to work with. I put the mirror in the middle of a white-walled area so it just reflected a clean background. Then we had to light the model so she looked good, but in such a way that the lighting setup would not be visible in the mirror. I also wanted viewers to be able to see a little bit of the mirror's frame so they'd realize that it was a reflection and not a twin. We showed her immediately what we were going for on the computer monitor and she loved it. Once she understood the feeling I wanted she got very creative in her attitude, too! In the first shot, it's clear that we were having fun—you can see that the model is laughing and communicating with herself. Some of these images really work for her portfolio, too, because it's very obvious how beautiful she is from virtually any angle.

I love working like this—a good model, a good concept, going with the flow, all while having a tremendous amount of fun. I can say I'm really surprised that the result was some really dynamic and lively professional-quality images. This is beauty with a twist. And, it teaches a very good lesson that's essential if you're determined to be a successful pro. To create fresh images consistently, you have to experiment from time to time. Otherwise, you will get in a creative rut that is too comfortable and ultimately boring!

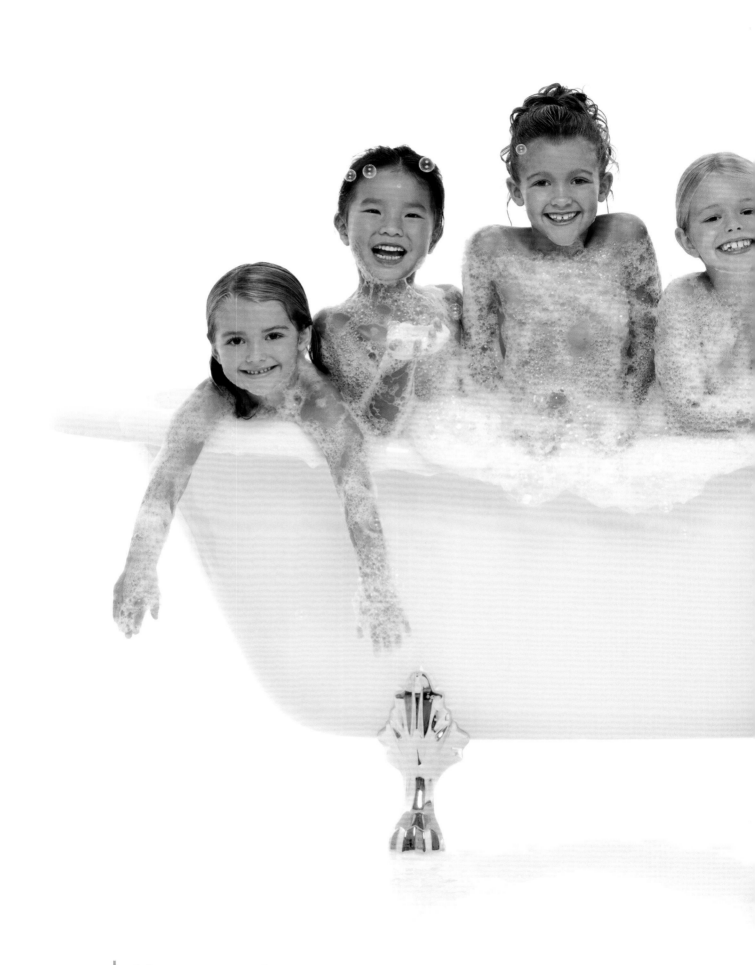

Legal Matters

Copyright

Putting your name, the year, and a "©" symbol somewhere on your images will protect your intellectual property from unauthorized use—to a certain extent. Should an infringement occur, you would be entitled to actual damages (which usually includes monetary compensation). Many artists choose to go a step further than that and register their images with the Copyright Office. To do this, go to http://www.copyright.gov/forms. If your images are registered with the government, and someone uses them in an unauthorized way, they will be liable for statutory damages.

Model Release

This is very important: You must have model releases for any person whose identity is clear in your pictures—that is absolutely necessary if the photo will be or has the potential to be used for commercial purposes. Generally, selling a photo at a gallery show is not considered commercial; but, if the image is used to advertise a product, that is definitely commercial use. Of course, stock agencies will require model releases for anything you submit because there is a very good chance that the pictures will be used in advertising. In any case, it doesn't matter whether it's your mother, your grandson, or a professional model—you've got to have releases. My mother has signed numerous releases. And when I submitted a shot of her with another woman sitting in a chair, I had to provide releases for both subjects. Written model releases are easy to obtain—you can download them online and most large photo stores sell pads of standard release forms at a modest cost.

Glossary

aberration

An optical flaw in a lens that causes the image to be distorted or unclear. The most common forms are spherical aberration, coma, astigmatism, curvature of field, curvilinear distortion (barrel and pincushion) and chromatic aberration.

acuity

The definition of an edge between two distinct elements in an image that can be measured objectively.

Adobe Camera RAW

An Adobe Photoshop plug-in allowing the conversion of RAW files into editable image formats.

Adobe Photoshop

Professional-level image-processing software with extremely powerful filter and color-correction tools. It offers features for photography, graphic design, web design, and video.

Adobe Photoshop Elements

A limited version of the Photoshop program, designed for the avid photographer. The Elements program lacks some of the more sophisticated controls available in Photoshop, but it does have a comprehensive range of image-manipulation options, such as cropping, exposure and contrast controls, color correction, layers, adjustment layers, panoramic stitching, and more.

ambient light

See available light.

angle of view

The area that can be recorded by a lens, usually measured in degrees across the diagonal of the film frame. Angle of view depends on both the focal length of the lens and the size of its image area.

aperture

The opening in the lens that allows light to enter the camera. Aperture is usually described as an f/number. The higher the f/number, the smaller the aperture; and the lower the f/number, the larger the aperture.

artifact

Information that is not part of the scene but appears in the image due to technology. Artifacts can occur in film or digital images and include increased grain, flare, static marks, color flaws, noise, etc.

artificial light

Usually refers to any light source that doesn't exist in nature, such as incandescent, fluorescent, and other manufactured lighting.

automatic exposure

An option in which the camera computer system measures light and adjusts shutter speed and lens aperture to create proper image density on sensitized media.

automatic flash

An electronic flash unit that reads light reflected off a subject (from either a preflash or the actual flash exposure), then shuts itself off as soon as ample light has reached the sensitized medium.

automatic focus

When the camera automatically adjusts the lens elements to sharply render the subject.

available light

The amount of illumination at a given location that applies to natural and artificial light sources but not those supplied specifically for photography. It is also called existing light or ambient light.

backlight

Light that projects toward the camera from behind the subject.

backup

A copy of a file or program made to ensure that, if the original is lost or damaged, the necessary information is still intact.

barrel distortion

A defect in the lens that makes straight lines curve outward away from the middle of the image, like the shape of a traditional wooden barrel. Also known as negative distortion.

bounce light

Light that reflects off of another surface before illuminating the subject. Usually done to soften the light as a technique in flash photography.

bracketing

A sequence of pictures taken of the same subject but varying one or more exposure settings, manually or automatically, between each exposure.

brightness

Intensity of light energy, measured by the amplitude of the light vibrations. See also, luminance.

buffer

Temporarily stores data so that other programs, on the camera or the computer, can continue to run while data is in transition. Also called a memory buffer.

built-in flash

A flash that is permanently attached to the camera body. The built-in flash will pop up and fire in low-light situations when using the camera's automated exposure settings.

built-in meter

A light-measuring device that is incorporated into the camera body.

bulb

A camera setting that allows the shutter to stay open as long as the shutter release is depressed.

card reader

A device that connects to your computer and enables the quick and easy download of images from memory card to computer.

CCD

Charge-Coupled Device. This is a common digital camera sensor type that is sensitized by applying an electrical charge to the sensor prior to its exposure to light. It converts light energy into an electrical impulse.

chrominance

A component of an image that expresses the color (hue and saturation) information, as opposed to the luminance (brightness) values.

chrominance noise

A form of artifact that appears as a random scattering of densely-packed colored "grain." See also, luminance and noise.

close-up

A general term used to describe an image created by closely focusing on a subject. Often involves the use of special lenses or extension tubes. Also, an automated exposure setting that automatically selects a large aperture (not available with all cameras).

CMOS

Complementary Metal-Oxide Semiconductor. Like CCD sensors, this sensor type converts light into an electrical impulse. Unlike CCDs, CMOS sensors allow individual processing of pixels, are less expensive to produce, and use less power. See also, CCD.

CMYK mode

Cyan, magenta, yellow, and black. This mode is typically used in image-editing applications when preparing an image for commercial printing.

color balance

The average overall color in a reproduced image. How a digital camera interprets the color of light in a scene so that white or neutral gray appear neutral.

color cast

A colored hue over the image often caused by improper lighting or incorrect white balance settings. Can be produced intentionally for creative effect.

color space

A mapped relationship between colors and computer data about the colors.

complementary colors

In theory: any two colors of light that, when combined, emit all known light wavelengths, resulting in white light. Also, it can be any pair of dye colors that absorb all known light wavelengths, resulting in black.

compression

A method of reducing file size through removal of redundant data. Comes in two forms: lossy (i.e. JPEG) and lossless (i.e. TIFF).

contrast

The difference between two or more tones in terms of luminance, density, or darkness.

contrast filter

A colored filter that lightens or darkens the monotone representation of a colored area or object in a black-and-white photograph.

critical focus

The most sharply focused plane within an image.

cropping

The process of extracting a portion of the image area. If this portion of the image is enlarged, resolution is subsequently lowered.

dedicated flash

An electronic flash unit that talks with the camera, communicating things such as flash illumination, lens focal length, subject distance, and sometimes flash status.

depth of field

The image space in front of and behind the plane of focus that appears acceptably sharp in the photograph. Determined by aperture, focal length, and subject distance.

diaphragm

A mechanism that determines the size of the lens aperture, and thus the amount of light that passes into the camera when taking a photo.

digital zoom

The cropping of the image at the sensor to create the effect of a telephoto zoom lens. The camera interpolates the image to the original resolution. However, the result is not as sharp as an image created with an optical zoom lens because the cropping of the image reduced the available sensor resolution.

download

The transfer of data from one device to another, such as from camera to computer or from computer to printer.

dpi

Dots per inch. A linear measurement of pixel density, referring to the number of dots or pixels in a linear inch. Used to define the resolution of a printer or a computer monitor.

DPOF

Digital Print Order Format. A feature that enables the camera to supply data about the printing of image files and supplementary information contained within them. The printer must be DPOF compatible for the system to operate.

electronic flash

A device with a glass or plastic tube filled with gas that, when electrified, creates an intense flash of light. Unlike a flash bulb, it is reusable. Also called a strobe.

electronic rangefinder

A system that utilizes the AF technology built into a camera to provide a visual confirmation that focus has been achieved. It can operate in either manual or AF focus modes.

EV

Exposure value. A number that quantifies the amount of light within an scene, allowing you to determine the relative combinations of aperture and shutter speed to accurately reproduce the light levels of that exposure.

EXIF

Exchangeable Image File Format. This format is used for storing an image file's interchange information.

exposure

When light enters the camera and reacts with the sensitized medium. The term can also refer to the amount of light that strikes the light sensitive medium.

exposure meter

See light meter.

extension tube

A hollow ring, metal or plastic, that can be fitted between the camera and lens. It increases the distance between the optical center of the lens and the sensor and decreases the minimum focus distance of the lens.

f/

See f/stop

FAT

File Allocation Table. This is a method used by computer operating systems to keep track of files stored on the hard drive.

file format

The form in which digital images are stored and recorded, e.g., JPEG, RAW, TIFF, etc.

filter

Usually a piece of plastic or glass used to control how certain wavelengths of light are recorded. A filter absorbs selected wavelengths, preventing them from reaching the light sensitive medium. Also, software available in image-processing computer programs can produce special filter effects.

firmware

Software that is permanently incorporated into a hardware chip. All computer-based equipment, including digital cameras, uses firmware of some kind.

flare

Unwanted light streaks or rings that appear in the viewfinder, on the recorded image, or both. It is caused by extraneous light entering the camera during shooting. Diffuse flare is uniformly reflected light that can lower the contrast of the image. Zoom lenses are susceptible to flare because they are comprised of many elements. Filters can also increase flare. Use of a lens hood, lens coating, or flare-cutting diaphragms can often reduce this undesirable effect.

f/number

See f/stop.

focal length

When the lens is focused on infinity, it is the distance from the optical center of the lens to the focal plane.

focal plane

The plane perpendicular to the axis of the lens that is the sharpest point of focus. Also, it may be the film plane or sensor plane.

focus

An optimum sharpness or image clarity that occurs when a lens creates a sharp image by converging light rays to specific points at the focal plane. The word also refers to the act of adjusting the lens to achieve optimal image sharpness.

FP high-speed sync

Focal Plane high-speed sync. An FP mode in which the output of an electronic flash unit is pulsed to match the small opening of the shutter as it moves across the sensor, so that the flash unit can be used with higher shutter speeds than the normal flash sync limit of the camera. In this flash mode, the level of flash output is reduced and, consequently, the shooting range is reduced.

f/stop

The size of the aperture or diaphragm opening of a lens, also referred to as f/number or stop. The term stands for the ratio of the focal length (f) of the lens to the width of its aperture opening. (f/1.4 = wide opening and f/22 = narrow opening.) Each stop up (lower f/number) doubles the amount of light reaching the sensitized medium. Each stop down (higher f/number) halves the amount of light reaching the sensitized medium.

full-sized sensor

A sensor in a digital camera that has the same dimensions as a 35mm film frame (24 x 36 mm).

GB

See gigabyte.

Gigabyte (GB)

A unit of computer memory just over one billion bytes (1024 megabytes).

GN

See guide number.

gray card

A card used to take accurate exposure readings. It typically has a white side that reflects 90% of the light and a gray side that reflects 18%.

grayscale

A successive series of tones ranging between black and white, which have no color. Also, an image with purely luminance data and no chroma information.

guide number (GN)

A number used to quantify the output of a flash unit. It is derived by using this formula: GN = aperture x distance. Guide numbers are expressed for a given ISO film speed in either feet or meters.

histogram

A two-dimensional graphic representation of image tones. Histograms plot brightness along the horizontal axis and number of pixels along the vertical axis, and are useful for determining if an image will be under or overexposed.

hot shoe

An electronically connected flash mount on the camera body. It enables direct connection between the camera and an external flash, and synchronizes the shutter release with the firing of the flash.

icon

A symbol used to represent a file, function, mode, or program.

image-editing program

See image-processing program

image-processing program

Software that allows for image alteration and enhancement.

infinity

In photographic terms, the theoretical most distant point of focus.

interpolation

Process used to increase image resolution by creating new pixels based on existing pixels. The software intelligently looks at existing pixels and creates new pixels to fill the gaps and achieve a higher resolution.

IS

Image Stabilization. This is a technology that reduces camera shake and vibration. It is used in lenses, binoculars, camcorders, etc.

ISO

A term for industry standards from the International Organization for Standardization. When an ISO number is applied to film, it indicates the relative light sensitivity of the recording medium. Digital sensors use film ISO equivalents, which are based on enhancing the data stream or boosting the signal.

JPEG

Joint Photographic Experts Group. This is a compression file format that works with any computer and photo software. JPEG examines an image for redundant information and then removes it. It is a variable compression format because the amount of leftover data depends on the detail in the photo and the amount of compression. At low compression/high quality, the loss of data has a negligible effect on the photo. However, JPEG should not be used as a working format—the file should be reopened and saved in a format such as TIFF, which does not compress the image.

KB

See kilobyte.

Kilobyte (KB)

A unit of computer memory just over one thousand bytes (1024).

latitude

The acceptable range of exposure (from under to over) determined by observed loss of image quality.

LCD

Liquid Crystal Display, which is a flat screen with two clear polarizing sheets on either side of a liquid crystal solution. When activated by an electric current, the LCD causes the crystals to either pass through or block light in order to create a colored image display.

LED

Light Emitting Diode. It is a signal often employed as an indicator on cameras as well as on other electronic equipment.

lens

A piece of optical glass on the front of a camera that has been precisely calibrated to allow focus.

lens hood

Also called a lens shade. This is a short tube that can be attached to the front of a lens to reduce flare. It keeps undesirable light from reaching the front of the lens and also protects the front of the lens.

lens shade

See lens hood.

light meter

Also called an exposure meter, it is a device that measures light levels and calculates the correct aperture and shutter speed.

lithium-ion (Li-ion)

A popular battery technology that is not prone to the charge memory effects of nickel-cadmium (Ni-Cd) batteries, or the low temperature performance problems of alkaline batteries.

long lens

See telephoto lens.

luminance

The amount of light emitted in one direction from a surface. It can also be used as luminance noise, which is a form of noise that appears as a sprinkling of black "grain." See also, brightness, chrominance, and noise.

M

See Manual exposure mode.

macro lens

A lens designed to be at top sharpness over a flat field when focused at close distances and reproduction ratios up to 1:1.

main light

The primary or dominant light source. It influences texture, volume, and shadows.

Manual exposure mode

A camera operating mode that requires the user to determine and set both the aperture and shutter speed. This is the opposite of automatic exposure.

megapixel

A million pixels.

memory

The storage capacity of a hard drive or other recording media.

memory card

A solid state removable storage medium used in digital devices. They can store still images, moving images, or sound, as well as related file data. There are several different types, including CompactFlash, SmartMedia, and xD, or Sony's proprietary Memory Stick, to name a few. Individual card capacity is limited by available storage as well as by the size of the recorded data (determined by factors such as image resolution and file format). See also, CompactFlash (CF) card, file format.

menu

A listing of features, functions, or options displayed on a screen that can be selected and activated by the user.

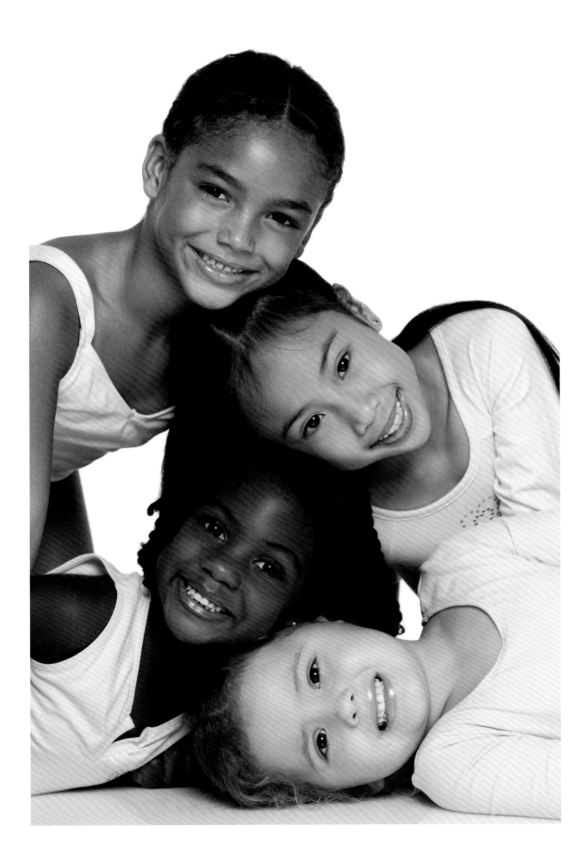

microdrive

A removable storage medium with moving parts. They are miniature hard drives based on the dimensions of a CompactFlash Type II card. Microdrives are more susceptible to the effects of impact, high altitude, and low temperature than solid-state cards are. See also, memory card.

middle gray

Halfway between black and white, it is an average gray tone with 18% reflectance. See also, gray card.

midtone

The tone that appears as medium brightness, or medium gray tone, in a photographic print.

mode

Specified operating conditions of the camera or software program.

moiré

An optical illusion that occurs when the frequency of detail of the subject interacts with the pixel pattern of a sensor. The resulting interference appears as a wavy pattern over the image.

noise

The digital equivalent of grain, appearing as random dots or changes in color value in an image. It is often caused by a number of different factors, such as a high ISO setting, heat, sensor design, etc. Though usually undesirable, it may be added for creative effect using an image-processing program. See also, chrominance noise and luminance.

normal lens

See standard lens.

operating system (OS)

The system software that provides the environment within which all other software operates.

overexposed

When too much light is recorded with the image, causing the photo to be too light in tone.

pan

Moving the camera to follow a moving subject. When a slow shutter speed is used, this creates an image in which the subject appears sharp and the background is blurred.

perspective

Visual cues in a two-dimensional image that give the impression of the three-dimensional space between the camera and image elements. Such cues include lines converging towards a vanishing point, aerial haze, difference sizes of common objects, different zones of focus, etc.

pincushion distortion

A flaw in a lens that causes straight lines to bend inward toward the middle of an image. Also called positive distortion.

pixel

Derived from picture element. A pixel is the base component of a digital image. Every individual pixel can have a distinct color and tone. All other things being equal, more pixels in a digital image results in higher quality, though this is affected as well by bit depth and pixel density.

plug-in

Third-party software created to augment an existing software program.

polarization

An effect achieved by using a polarizing filter. It minimizes reflections from non-metallic surfaces like water and glass and saturates colors by removing glare. Polarization often makes skies appear bluer at 90 degrees to the sun. The term also applies to the above effects simulated by a polarizing software filter.

pre-flashes

A series of short duration, low intensity flash pulses emitted by a flash unit immediately prior to the shutter opening. These flashes help the TTL light meter assess the reflectivity of the subject. See also, TTL.

Program mode

In Program exposure mode, the camera selects a combination of shutter speed and aperture automatically.

RAW

An image file format that has little internal processing applied by the camera. It contains 12-bit color information, a wider range of data than 8-bit formats such as JPEG.

RAW+JPEG

An image file format that records two files per capture; one RAW file and one JPEG file.

rear-curtain sync

A feature that causes the flash unit to fire just prior to the shutter closing. It is used for creative effect when mixing flash and ambient light.

red-eye reduction

A feature that causes the flash to emit a brief pulse of light just before the main flash fires. This helps to reduce the effect of retinal reflection by causing the subject's pupils to contract.

resolution

The amount of data available for an image as applied to image size. It is expressed in pixels or megapixels, or sometimes as lines per inch on a monitor or dots per inch on a printed image.

RGB mode

Red, Green, and Blue. This is the color model most commonly used to display color images on video systems, film recorders, and computer monitors. It displays all visible colors as combinations of red, green, and blue. RGB mode is the most common color mode for viewing and working with digital files onscreen.

saturation

The degree to which a color of fixed tone varies from the neutral, grey tone; low saturation produces pastel shades whereas high saturation gives pure color.

sharp

A term used to describe the quality of an image as clear, crisp, and perfectly focused, as opposed to fuzzy, obscure, or unfocused.

short lens

A lens with a short focal length—a wide-angle lens. It produces a greater angle of view than you would see with your eyes.

shutter

The apparatus that controls the amount of time during which light is allowed to reach the sensitized medium. That amount of time is called the shutter speed.

Shutter-priority mode

An automatic exposure mode in which you manually select the shutter speed and the camera automatically selects the aperture.

Single-lens reflex

See SLR.

slow sync

A flash mode in which a slow shutter speed is used with the flash in order to allow low-level ambient light to be recorded by the sensitized medium.

SLR

Single-lens reflex. A camera with a mirror that reflects the image entering the lens through a pentaprism or pentamirror onto the viewfinder screen. When you take the picture, the mirror reflexes out of the way, the focal plane shutter opens, and the image is recorded.

small-format sensor

In a digital camera, this sensor is physically smaller than a 35mm frame of film. The result is that standard 35mm focal lengths act like longer lenses because the sensor sees an angle of view smaller than that of the lens.

standard lens

Also known as a normal lens, this is a fixed-focal-length lens usually in the range of 45 to 55mm for 35mm format (or the equivalent range for small-format sensors). In contrast to wide-angle or telephoto lenses, a standard lens views a realistically proportionate perspective of a scene.

stop

See f/stop.

stop down

Reduces the size of the diaphragm opening by using a higher f/number.

stop up

Increases the size of the diaphragm opening by using a lower f/number.

strobe

Abbreviation for stroboscopic. An electronic light source that produces a series of evenly spaced bursts of light.

synchronize

Causing a flash unit to fire simultaneously with the complete opening of the camera's shutter.

telephoto effect

When objects in an image appear closer than they really are through the use of a telephoto lens.

telephoto lens

A lens with a long focal length that enlarges the subject and produces a narrower angle of view than you would see with your eyes.

thumbnail

A small representation of an image file used principally for identification purposes.

TIFF

Tagged Image File Format. This popular digital format uses lossless compression.

tripod

A three-legged stand that stabilizes the camera and eliminates camera shake caused by body movement or vibration. Tripods are usually adjustable for height and angle.

TTL

Through-the-Lens, i.e. TTL metering. Any metering system – ambient exposure or flash – which works through the lens. Such systems require sensors built into the camera bodies with beam splitters to transfer incoming light to the sensor systems.

Tv

Time Value. See Shutter-priority mode.

USB

Universal Serial Bus. This interface standard allows outlying accessories to be plugged and unplugged from the computer while it is turned on. USB 2.0 enables high-speed data transfer.

vignetting

A reduction in light at the edge of an image due to use of a filter or an inappropriate lens hood for the particular lens.

viewfinder screen

The ground glass surface on which you view your image.

VR

Vibration Reduction. This technology is used in such photographic accessories as a VR lens. Similar to image stablization.

wide-angle lens

A lens that produces a greater angle of view than you would see with your eyes, often causing the image to appear stretched. See also, short lens.

Wi-Fi

Wireless Fidelity, a technology that allows for wireless networking between one Wi-Fi compatible product and another.

zoom lens

A lens that can be adjusted to cover a wide range of focal lengths.

Index

Notes

Notes